A Best Half of Life® Book

Videotape
Your
Memoirs

A Best Half of Life® Book

Videotape Your Memoirs

The Perfect Way to Preserve Your Family's History

by
Suzanne Kita
&
Harriet Kinghorn

Quill
Driver
Books

Sanger, California

Quill Driver Books/Word Dancer Press, Inc.
1831 Industrial Way #101
Sanger, California 93657
(559) 876-2170
800-497-4909

QuillDriverBooks.com

Printed in the United States of America

Quill Driver Books/Word Dancer Press books may be purchased in quantity at special prices for educational, fund-raising, business, or promotional use.
Please contact:

Special Markets
Quill Driver Books/Word Dancer Press, Inc.
1831 Industrial Way #101
Sanger, California 93657
800-497-4909
Info@QuillDriverBooks.com

Quill Driver Books/Word Dancer Press, Inc.
Project Cadre:
Doris Hall • Dave Marion • Stephen Blake Mettee • Brigitte Phillips • Linda Kay Weber

❧

ISBN 1-884956-25-4

Library of Congress Cataloging-in-Publication Data

Kita, Suzanne.
 Videotape your memoirs : the perfect way to preserve your family's history / by Suzanne Kita and Harriet Kinghorn.
 p. cm.
 ISBN 1-884956-25-4 (Trade paper)
 1. Video recording--Amateurs' manuals. 2. Videorecordings--Production and direction--Amateurs' manuals. 3.Camcorders--Amateurs' manuals. I. Kinghorn, Harriet R., 1933-
II.Title.
 TR896 .K52 2002
 778.59--dc21

 2002005139

Contents

4

5

6

7

8

9

Acknowledgments

We wish to gratefully acknowledge Stan Lukowicz of Four Reel Production and Donna Grissom for sharing their expertise with us on the technical video production areas of this book. Our husbands, Len Donelson and Robert Kita, have also lent their love and never-ending support to this project.

1

Your Memoirs Are Important

🙠 *Have you ever wished you knew more about your parents' or grandparents' lives or even the lives of close friends? Have you wished that they had recorded and passed on to you the stories of their lives?*

🙠 *Have you ever taken time to think about your own experiences, those that made you who you are?*

🙠 *When was the last time you vowed to write your own memories, yet put aside the immediate urge, unsure of how to begin?*

If these questions make you feel the need to take action, then this book is for you. In *Videotape Your Memoirs*, we will

- examine the motives many adults have for sharing their stories;
- explore the intrinsic values of reviewing your life's journey;

- encourage you to identify and retrieve the significant, colorful, and entertaining memories of your own life;
- recommend videotaping as an easy, innovative method of transcribing these stories;
- explain how you can capture, preserve, and share a lasting legacy with those you love.

Why do we feel compelled to pass on the stories of our lives? It's human nature to want to form a meaningful link between ourselves, those who have gone before us, and those who will follow us. Long before the use of written language, humans kept life histories and traditions alive through story telling. A few generations ago, families lived close together and often spent entire lifetimes in the same community. It was easier for people to know each other's histories then and to keep memories alive. Now our society has become more mobile. Family members often no longer live in the same communities. Our lives have become busier, with many more demands on our attention. This means there are fewer opportunities and less time for sharing reminiscences.

> *Have you ever wished you knew more about your parents' or grandparents' lives, or the lives of your close friends?*

Significantly, having little information available about our ancestors' lives creates a void in our own histories. Often all that remains of those who preceded us are tattered photos and entries in the family Bible. Many times we think about these ancestors and ask ourselves: What would it have been like to live in Grandma's time? Or, what was Aunt Johnnie like?

How many times have we wished we could remember Granddad's story about how he and Grandma met?

How often have we wished we could fully appreciate the influence great-aunts and uncles have had on our lives?

If you had your father's or mother's autobiography, wouldn't you consider it to be among your most prized possessions? While you may no longer be able to fill this particular void, you can ensure that your heirs will not suffer the same sort of loss. By creating your memoirs, you are giving your loved ones the chance to see you as a real person during the various stages of your life—and as you are now—and to learn about the significant events and changes of your life. Leaving your memoirs is a gift that only you can give, one that those close to you will treasure. Otherwise, much will be lost forever.

> "Memory is the crux of our humanity. Without memory we have no identities. That's really why I am committing an autobiography."
> —Erica Jong

Of course, you need to believe that your life's journey has been unique, interesting, and important. Unfortunately, many of us hedge on this. "Oh, my life has been ordinary," we say. "There's nothing special about it."

On the contrary, each person's life is too valuable to go unrecorded or to be forgotten. Your experiences are your own greatest treasure. No matter who we are or what sort of life we've lived, we all have intriguing stories to tell.

What kinds of stories might you share? First, you'll want to describe the facts—and, just as important, your feelings about the turning points of your life, the peaks and valleys. In fact, you may wish:

• to create a personal history set in the scope of larger circumstances and events, placing yourself in relationship to the big-

ger picture of the history of your family, your local community, and your world;

 • to explain your actions and beliefs, the why behind what has happened in your life (maybe just to set the record straight);

 • to focus on what the past means to you now, the ways in which it has affected you, and what lessons you have learned;

 • to share the wisdom you have gained along the way, or the truth as you see it now;

 • to entertain others with some of your favorite anecdotes and jokes, so that they will be acquainted with your sense of humor and perspective;

 • to share the tragedies you have lived through and moved beyond.

A memoir is exactly what you want it to be. The only requirement is that it describes and defines you and your experiences.

 How long has it been since you've taken time to think about your own experiences, those that have made you who you are?

Many people find the process of recording their memoirs therapeutic. Often, reflective sharing creates new levels of intimacy and bonding with those you love. There are many intrinsic values in the retelling process. An important first step in reassembling segmented events and reconstructing the many elements of your history is to set aside time for reflection and remembering.

As you go through the process of recording your memoirs, you may gain new perspectives on the forces that have shaped you and form new connections with your former selves. You may see events and people in a new light, discover patterns in the mis-

takes you made, the lessons you learned, and in the ways you adapted to change and dealt with unanticipated events. You will undoubtedly uncover memories long forgotten, revisit joyful moments, and feel pride in your accomplishments.

> *When is the last time you vowed to record your own memories, yet put aside the immediate urge, unsure of how to begin?*

"While we are postponing, life speeds by."
—Seneca

Since you have picked up this book and read this far, you probably are inclined to create some form of meaningful memoir. Beware that your inner censor may try to dissuade you from this undertaking. Don't put off what will be an entertaining and rewarding experience, although memoirs can be at times as painful as they are pleasurable. *Now* is a good time to start jotting down notes. Cast out your trepidation and plow ahead. As we proceed, this book will help you feel comfortable and confident that this is a doable and rewarding project.

Why do we recommend videotaping your memories? Videotapes can capture your memoirs more completely than a still camera, audio recording, or words on a page.

Now, you can tell the story of your life, produced in whatever segments or chapters you determine, and videotaped at whatever locations you choose. For instance, you can stand in front of the house in which you were born, swing on the porch swing where you were courted, walk the hallways of your high school or sit in the bleachers of the old football stadium.

In a video, the viewer hears actual sounds, both the voice of the speaker with all its nuances and speech patterns and the background sounds, perhaps the peal of thunder or the chirping of

birds or the roar of waves on the shore. You can even have music playing in the background.

Videotaping lends unparalleled richness and depth to your message. A good video brings memories to life, showing the mannerisms that makes you special. As you tell you stories, it will be *as if you are there* with the viewers. And, your video presence can be enjoyed again and again for years to come.

Another reason for videotaping rather than writing is that you can dispense with the tedium of penning or word processing line after line, page after page. You won't be bogged down by worries about paragraph structure, spelling, punctuation, and capitalization. Instead, as you spend time reflecting and remembering, jot down notes and keywords on a note pad to help remind yourself what you want to recount once you begin.

For handicapped people, videotaping may be the best way to record memories. Physical handicaps may preclude or make writing difficult. Videotaping allows you to avoid physically tiring or physically impossible hurdles. Also, for the person who speaks English as a second language but hasn't confidence in his or her ability to write in English, videotaping is a godsend. Consider recording the videotape twice, once in your original language and again in English.

Now that you're sold on the idea, we'll show you how to select and prepare your equipment and yourself for the videotaping. Never fear! You need nothing more than a video camera, a supply of videotapes, a tripod, and your memories to create a true legacy and an invaluable life history that is irreplaceable and priceless.

2
Selecting Your Equipment

If you are unfamiliar with video cameras and taping, you may feel overwhelmed by the thought of all the technology involved. But you needn't be. If you take the approach one step at a time, you'll begin to see it is not at all overwhelming.

Video cameras have become virtually foolproof, and you need not be at all intimidated by them. If you feel you need instruction and practice in their use and in videotaping techniques, there are many people who are experienced with video cameras and will surely advise you; someone in your own extended family or a neighbor is very likely to have a video camera and to know how to use it. Many camera stores, adult education programs, and local university extension programs offer classes that will give you the basic techniques, and once you understand these techniques, all you need is a little practice on your own.

First you need to decide what video camera and accessories you will need and who else, if anyone, will need to be involved in your videotaping sessions. You'll also need to decide on the place or places you'll do your videotaping and what objects or props you'll employ. These are the considerations and possibilities we will explore in this chapter.

After reading this chapter, you will have the information you need, and you should feel comfortable about planning the technical aspects of the project.

The Camcorder

A camcorder is a CAMera plus a videotape reCORDER. Today's units combine synchronized, full-color pictures and sound that can be immediately replayed in the camera's view finder, or using a VCR, or, via a simple cord, called a "lead," on your TV's screen.

If you're buying a camcorder system, you'll have lots of choices in camera size, tape formats, desirable features, playback mode, and cost. Keep in mind that you can save money by purchasing a basic model. Or, if cost is not a major drawback, you may like all the bells and whistles such as slow motion, stop action, zoom in and zoom out; however, remember these bells and whistles can add complications as well as neat effects.

Before purchasing a new camera, you may even wish to look at used cameras. Many excellent cameras are sold by people wishing to upgrade to the most recent model. Before purchasing a used camera, try it out and examine the warranty. Of course, you may be able to borrow a camera from a friend or relative. Most video camera owners use their cameras only occasionally and are happy to loan them. If you can borrow a video camera, don't forgo the opportunity out of concern that you may destroy it. As mentioned earlier, most video cameras are nearly foolproof and unless you drop it, you will not likely hurt it during use.

Another possibility is to rent a camera. Check your Yellow Pages for "Audio Visual Equipment Renting."

Today there are ten camcorder formats. Tomorrow there will

probably be more. Each has its own advantages and disadvantages. Try out the different types to determine which best fits your needs. Lift each camera to feel its weight and balance. The controls should be manageable in your hand and the position of the view finder comfortable to your eye. Then actually record and play back a tape, experimenting with the features. Be sure to inquire about support procedures, as most manufacturers offer call-in and Internet support.

A brief explanation of each of the ten different camcorder types follows.

Your Camcorder Choices

VHS (Video Home System): These have been popular for a long time because the half-inch tapes can be played in any VHS VCR. Advantages include long playing time, stereo and mono modes, and features allowing for separate audio dubbing and insert editing. However, VHS has lower resolution than many other formats, and the camcorders are heavy and bulky. The latter is not a problem if you intend to mount the camera on a tripod or atop sturdy furniture during taping.

VHS-C (Compact): Here, a shorter length of the same VHS half-inch tape is housed in a smaller, lighter case which is easier to handle than the VHS camcorder. With a relatively inexpensive VHS-C adapter, the tapes can be replayed in a full-sized VHS player. The camcorders can also be plugged directly into a TV monitor. You can increase the recording time of the forty-minute tapes to two hours by using the standard long-play function if your VCR has the long-play mode. However, the slower your recording speed, the lower the resolution, in any format. The same VHS advantages apply in the VHS-C format regarding mono/ste-

reo options, audio dubbing and insert edit features. VHS-C also has the same disadvantage of lower resolution picture.

S-VHS: While this camera and tape look identical to a standard VHS, the high-band format offers superior picture quality with greater resolution, better color and sharper images. The tapes are much more expensive than standard VHS tapes, but they run for two hours. They can be played only through the camcorder or an S-VHS VCR.

S-VHS-C: This is another high-band VHS-C which is more compact than the S-VHS. The forty-five-minute tape's playing time can be doubled in a long-play mode. Most S-VHS-Cs have hi-fi stereo sound tracks and redubbable mono tracks.

8mm: The metallic one-third-inch tape for this camcorder is the longest playing currently available, recording two hours in standard play or up to four hours in the long-play mode. Cassettes and housings are small and lightweight. However, tapes cannot be played back in a VHS VCR. Rather, you have to plug the camera into the TV to view the recordings. Or, you can plug the camera into a VCR and make a new VHS conversion tape. High quality sound is recorded simultaneously with videotaping, but no audio dubbing or insert editing is possible.

Hi-8: Used by professionals and users who want a higher quality image, this device's high-band 8mm tape records a better signal than the other camcorder options. You view the tapes via your TV unless you purchase a costly VCR that is able to play them. Expect to pay two to three times more for a blank Hi-8 tape than for the 8mm tape. Again, most of these camcorders have no audio dubbing or insert edit features.

Mini DV (Digital Video): One of the newer tape formats on the market, the Mini DV camera is small and records with high quality. Tapes are the size of a microcassette or minicassette and

each records for one hour. Since the image is recorded digitally, it can be transferred directly into most of the newer computers for desktop video editing. Viewing is via either your television or your computer monitor.

Digital8: Another digital format, this one records with a very clear picture and no reduction in quality with copying. But it uses 8mm cassettes instead of mini-DV. Any 8mm recording will play on this recorder.

MiniDisc: This format avoids tapes altogether, recording onto mini computer discs. As with other digital formats, there is no quality loss with copying, and editing can be done on the computer.

DVD-RAM: This is the newest type of format (as of press time). This camcorder is typically smaller and lighter than most other formats, and has more recording time.

There are many great special effects features available with today's video cameras. Do not be intimidated by the terminology used with special effects features. The owner's manual will clearly explain all special effects features. The following are a few features that might be pertinent to the creation of your video memoirs:

• In some cameras, the view finder offers a black/white image, even though the tapes are recording in full color. However, most newer cameras feature a color view finder which can be adjusted to your eyesight.

• A "Full Auto" feature resets all controls to automatic.

• A CCD (charge coupled device) is an imaging chip which enhances details.

• The color view finder and/or LCD screen can be turned and twisted so that the photographer can experiment with the image from creative angles.

• A "Black and White" option removes all of the color from the images.

• "Sepia Tone" removes all the color except for brown tones, reminiscent of the photos from the "old days."

• "Auto White" balance helps the camera record colors the way our eyes see them and can be set differently for indoor and outdoor shooting.

• Many cameras have a built-in clock. By activating the date function, you can record the date and time on the recordings.

• The "Freeze Frame" allows you to pause on an image, highlighting a gesture or facial expression of the subject.

• The "Fader" causes the picture to fade away, leaving a plain white or black screen. This is a good way to mark transition between scenes or the segments of your memoirs.

• The "Low Light" setting boosts the video signal in dimly lit areas, but results in a grainier, poorer quality picture and probably will not be needed for your purposes.

• Most cameras have a "Backlight" feature which opens the lens iris to a fixed setting to compensate for undesirably bright backlighting.

• A flying erase head allows a clean edit for every start and stop, with no dead tape in between.

• All camcorders come with a zoom lens which enables the photographer to alter the focal length and the size of the image.

• Most have a motorized rocker switch which allows a shift between wide angle and telephoto settings. A 6-20X zoom feature is adequate for most videotaping situations, especially the interview scenes you will use in creating your memoirs.

You activate most special effects features one at a time by pushing a button on the camera or by using an on-screen menu option. A few cameras allow the user to combine two special ef-

fects simultaneously. Again, the owner's manual will explain all special features of the video camera you select.

If you choose to use an older camcorder, keep in mind that the colors may not be as vivid or rich as they are with a newer model, and the sound may not be as crisp and clear. There also is the chance that an older camcorder could stop working in mid-project. Whether you use an older or new camera, it's always a good idea to have access to a backup camcorder in case the equipment fails in the middle of a session. Even with one camera, if something does go wrong, you probably won't lose the entire segment. In most cases, you can pick up where you left off. Just be consistent with your background and lighting conditions to maintain continuity. In any case, there are many creative ways to edit mistakes and glitches (see Chapter 8: Editing).

Videotapes

The quality of your recordings depends upon the type of blank tapes you use in your camcorder. Beware of using inexpensive VHS tapes for a project as important as this one. Your memoirs should be recorded on tapes that will provide brilliant images that will last a long time. Always have extra blank videotapes available in case your taping requires more footage than you anticipated.

Tripod or Monopod

It is best to use a tripod or monopod to ensure a steady shot. However, you can also stabilize your camera on a sturdy piece of furniture. When using a tripod, be sure that the lens is set on the same level as the eyes of the subject. Shooting up or down can exaggerate lines and shadows on the face. If more than one per-

son is being interviewed and their eyes are at different levels, adjust the camera lens to a level between the two.

If you are not using a tripod, many new cameras now offer digital stabilization, which compensates for jerky camera movements, a common problem with smaller hand-held camcorders.

Lighting

Your camcorder can shoot in very low light. Usually, however, the more light, the better. If you are videotaping indoors, turn on every light in the room. If the room is usually softly lighted, change the bulbs to those with a higher wattage. If possible, light the subject from the front, or else place the person near a light. To avoid side shadows, you can create diffuse lighting by shining a spotlight on the ceiling. Remember that the subject should be the brightest spot in the framed image.

Avoid videotaping anyone in front of bright light, such as standing in front of a window. Such a backlit subject will often appear as a dark silhouette. Many cameras adjust for this backlighting automatically, but it may be desirable to have a camera with a manual adjustment in extreme situations that exceed the camera's automatic backlighting feature's capabilities.

If necessary, an auxiliary light can be mounted on the top of your camera. A good one will have its own battery source. Less expensive lights share the camera's battery and drain its power. Auxiliary lighting is helpful both indoors when light is dim or when shooting outdoors after sundown.

Sound

Today's camcorders all come with sensitive built-in microphones, so there is usually no problem with recording voices un-

less the speaker uses very soft, whispery tones. Background noise is sometimes hard to filter out. If shooting outdoors, wind and peripheral noise such as passing automobiles can be a problem. On the other hand, some outdoor sounds, such as birds whistling or water trickling in a stream, may be a positive addition to the videotape session. Some cameras offer a setting on the microphone called "boom," "telephoto" or "shotgun" which focuses and captures the audio just from the direction in which the camera is pointed.

All cameras have a microphone jack which allows connection to an auxiliary microphone. Using an auxiliary microphone can substantially improve the sound quality of your tapes. Some microphones can be clipped to a person's upper body clothing to help reduce background noise. Stand-alone directional shotgun microphones can also be plugged in to the camera. These microphones are relatively inexpensive and can be found at larger camera stores.

Other Accessories

Every camcorder should have a clean protective case. Dust, sand, water, strong sunlight, indirect heat in a hot car, direct heat from lamps, and exposure to magnetic fields can all damage your video camera.

When the camera is not in use, the rechargeable battery should be removed and stored in a clean, dry container (after recharging it, of course). In case the one you are using weakens or dies during videotaping, always keep an extra battery charged. A battery charger plugs into an electrical outlet; when not in use, it should be stored in a case or plastic bag to prevent short-circuiting. When using an older battery charger, run the battery down as much as possible before recharging it; recharging a battery

that is not fully discharged can shorten its overall life. Many of today's battery chargers automatically discharge the batteries before recharging, so the user needn't worry. With reasonable care, batteries can be recharged at least 500 times. Realize that if you use special features, each consumes additional battery power.

A cable can facilitate the use of the camera from a main power source via the battery charger, thus saving on battery consumption. An AV lead connects the camera to the TV or VCR; an RF lead can be used for this purpose if the TV has no AV socket.

If your camera has an internal clock, you may need a lithium battery to run it.

Most video camera retailers will be happy to teach you the use of the equipment. While some salespersons are experts, others know very little about the products they sell. Be your own judge of their competencies and talents.

3

Choosing Your Format and Crew

You will be the star of your show, but you may want to recruit some help and make the recording of your memoirs an enjoyable family or group project.

One Person Format and Crew (You Alone)

If you wish to go "solo," set your stage and frame your image in the view finder of a solidly mounted video camera, then test the framed image of yourself. If your camera has a self-timer, set it to allow you to move from behind the camera to your position in front before recording begins. Most self-timers allow for a ten-second delay. Certain camcorders have remote controls that are ideal for this purpose. Videotape yourself telling your stories in short segments, referring to notes and props as necessary.

Two Person Format and Crew

You may decide to have one person operate the camera while also serving as the off-camera interviewer. The questions are recorded on the audio while your image remains framed by the camera.

Three Person Format and Crew

If two other people can help, you and your interviewer can both be framed within a single shot. The third person can operate the camcorder. The interviewer will ask you questions.

Group Interview Format and Crew

Yet another interview format is for you to answer questions and tell your stories as the center of a small group conversation, with the group scene framed by a camera operator who can zoom in on various speakers for special effect.

Professional Crew

You may wish to hire a professional videographer. We have included ideas for locating one in the "Resources" section at the end of the book.

You may wish to mix and match these formats, using a bit from two or more. For instance, you may choose to go it alone for the early parts of your memoir and then invite others, perhaps your spouse, child, or best friend, to join you as you get to the part of your memoir that pertains to each of them.

4

Videotaping Techniques and Tips

Videotaping any subject requires designing an interesting visual composition. Before setting up your own taping sessions, notice some of the techniques used by TV professionals. How are the shots framed? How are interviews managed?

To create effective, interesting images which offer a variety of balance, shape and form, consider some of the following tips.

Framing

What you see in the view finder is what you get on tape. The square TV screen usually provides your viewing boundaries.

You can occasionally use foreground frames for variety. For example, framing the subject in a door or window enhances the visual interest. You might even want to experiment with a mirror shot, capturing the subject's reflection as the focal point or as part of an expanded scene.

Vary the use of long, medium and close-up shots. In a medium-long shot, a standing person's image is completely visible in the frame. The mid-shot pictures the person from the waist up. A close-up would show just the head and shoulders.

Close-ups

We highly recommended using close-ups for much of the videotaping of your memoirs, since a person and his or her story telling are the desired focus. Not only will close-ups create a greater feeling of intimacy, but they will reduce any irrelevant background clutter. A medium close-up includes the subject's chest and head. You can zoom in further to feature the head and shoulders or go for a full face shot. Be certain, however, that the subject in a close-up doesn't use expansive gestures or shift positions or the image could go off screen. Allow some space on either side, above, and below for the subject's movement. Variety here will add interest, but don't overuse the zoom during the actual recording.

Rule of Thirds

Place your subject away from the dead center of the frame. Divide the frame equally by two vertical lines and two horizontal lines, then place your subject at any of the four points where the lines intersect. This provides more interesting composition than does a center shot.

Headroom

Avoid creating visual imbalance by putting the subject's head in the horizontal center of the frame. Better placement leaves just a little space above the head, allowing some of the shoulders into the image.

Eyelines

The subject may wish to look directly at the camera or slightly to one side. When taping people in conversation, the camera should

stay on the same side of the subject's eyeline, the imaginary line along the axis of a person's gaze.

Two subjects having a conversation or in an interview should be looking in opposite directions for successive shots; otherwise, they might appear to be ignoring each other. Leave more space in front of a three-quarters or profiled face than behind it so that the eyes do not appear to be crowded too close to the edge of the frame.

Changing Angles

A sense of depth can be created by videotaping group shots from a high angle, looking downward. This would be a great technique for videotaping large groups or reunions, but not for an interview or an individual's story telling. If you want to tilt the camera down or up—for example, from the subject's face to his or her hands—using a tripod with a crank will create a smooth transition.

Panning

Don't swing the camera back and forth between subjects during an interview. If you wish to pan (move horizontally from one subject to another), do so only after a three second hold. Rapid, too-frequent panning will create dizziness and disruption for the viewer.

Rostrum Taping

If you want to intersperse a narrative or interview with close-up shots of objects or props, place them stationary on a flat table

or rostrum. Light them from above and all sides. Then aim the camera down to record the image. If you pan, do so very slowly.

Filming in Segments

One common mistake that new videographers make is taping *lengthy* segments. Shoot for only ten to twenty minutes, then relax a bit before continuing, perhaps using a different slant. To avoid "jump cuts," that is, sudden breaks

> "What peaceful hours I once enjoyed! How sweet their memory still!"
> —William Cowper

between segments, end the shot with a cutaway, a fade, or some other change. It's usually difficult to recapture exactly the same posture and position when taping resumes. At least try to frame the next shot from the same general direction; don't end with a right angle shot and restart with a left angle shot.

You should realize that every time the pause button is activated, the camcorder rewinds over the previous two seconds' recording. If you plan to edit your videotaped segments, allow extra time at the beginning and end of each segment so that the VCR backspacing element won't wipe out important material. Be sure to catch sentences completely, allowing several seconds at the beginning and end of each pause during the taping.

Don't accidentally leave your camcorder turned on when you break between segments or you'll use valuable footage on nonsense and have to edit it out later.

5

Helpful Hints for Video Storytellers

Now that you have decided which equipment to use and who will be involved in the videotaping, most likely, you still have a few questions, things like:

> "What stories shall I tell?"
> "How can I organize my thoughts and tales?"
> "What will be the topic of my first session?"
> "What story-telling style should I use?"

In this chapter we offer suggestions for selecting and preparing the content for each videotaping session and present helpful hints for finding and getting comfortable with your video story telling style.

Be assured that there will be no shortage of things for you to talk about. In Chapter 7, "A Lifetime of Stories to Tell," we offer hundreds of questions and prompts which will help you recall the full range of your life's experiences and a lifetime of feelings. Use the headings and contents of each section as triggers for your memory. As you consider the possibilities, your memories will be revitalized and invigorated with details which will become even richer as you dwell on them.

Starting Places

You may be thinking: Where to begin? Where to focus? Where to end? The answer is wherever you want! Some people prefer to record their memories chronologically. A good starting point in this approach is to create a simple outline of the ten signal events of your life. Others prefer spontaneous or topical recordings which can be grouped and sequenced later. Wherever you choose to begin, be sure that by the time you reach the end you have included the basics of your autobiography, providing as many specific details as you can about yourself, your life, and your family.

Go beyond the landmark events of your life to the thematic topics which will allow others to know you as an individual much more fully. What will be especially precious for loved ones to discover is the inner you—your thoughts, opinions, tastes, likes, and dislikes; your untold adventures, the tough times you have experienced, and the secrets that you now share.

Don't just present facts; describe your feelings, as well. Even as you talk about what you have planned, you may discover some great additional ideas which we haven't mentioned in Chapter 7. Many people initially fear that they have little to say, but soon discover that each memory snowballs into additional memories. Let your memories lead the way!

After reviewing our many suggestions and your own ideas, select one topic which interests you most. Ignore the elements that don't apply, but linger over those that do. A few days before taping your first segment, start thinking about what you might say about this topic, about what props—memorabilia, pictures, pieces of clothing—you might use for show. Try to recapture old feelings about these events or topics. Jog your memory by looking at old photographs, scrapbooks or antiques. Rummage through the attic. Talk with family or friends about your topic in order to

verify, amplify, or vivify your impression. If possible, revisit important places—the house where you grew up, the church where you were wed, the stream where you lost the trophy fish.

Tap into a flood of memories, allowing your subconscious to augment the conscious efforts you make. Sit quietly, close your eyes, and open your mind to the details and sensory impressions of remembered experiences or revived feelings or ideas. Recapture tastes, smells, and sounds. When you think of an event, a situation, or a person, what sensory details come to mind?

> "The art of memoir is all in the business of remembering and in the art of retelling."
> —Ray Mungo

Jot Notes, Make Lists

Memory flashes come in bits and pieces, surfacing at odd, unpredictable times, so be prepared. Keep a notebook handy to capture those thoughts before they disappear. List words which come to mind relevant to this particular memory. Sketch images. If an unrelated thought surfaces, jot it down anyway; it may belong somewhere later.

Develop a list of the stories you want to tell and topics you want to cover. Begin to organize the small story segments into an outline for your memoirs using any pattern that suits your purpose and fancy.

Most of us tell stories continually and spontaneously in our everyday lives. However, while the videotape memoir allows you the liberty to plan and categorize your stories, it also can create a sense of artificiality, of a forced, formalized presentation. Before you tape your first segment, review the following suggestions which will help you create natural, lively video vignettes:

- Talk to the camera or to the interviewer in a conversational, unrehearsed manner. There's no need to create or read from a script, though you may want to refer to your notes occasionally.

> "Autobiography begins with a sense of being alone."
> —John Berger

- Get personal. Express candidly and with enthusiasm your feelings and opinions about events, people, and topics.

- Share specific sensory details, creating colorful pictures for the listener. Use these details to enable the listener to "see" what you are describing.

- Use dialogue and dialect, sharing what people said in the way that they said it.

- If you use jargon or words that might be unfamiliar to the listener, explain those terms (dancing the Charleston, bobbed hair, war rationing).

- Of course, you may not want to include *everything* in your memoirs...or will you?

- Don't avoid conflict or try to sugarcoat circumstances. Life's journey is spiced with ups and downs, celebrations and challenges, triumphs and traumas.

- Be discreet about sensitive issues. Be honest, but don't be hurtful or mean-spirited so that you inflict pain or open old wounds.

- Find a natural flow for your thoughts. Try not to seem as if you are working through a checklist.

- Keep your sentences short. Indulge in some freewheeling associations, but stick to the topic and avoid rambling and redundancies. (If sudden memories kick in and throw you off subject, it's okay. You can always edit later—and save the memory to use elsewhere.)

- Don't worry if you become teary-eyed or emotional. Your

emotions and body language speak more loudly than your words. *Show* as well as *tell* who you are.

• Let your hair down. Don't be shy about laughing and joking on camera.

• Above all, have fun! Enjoy yourself and what you're doing.

6

Videotaping Your Memoirs

Now you are ready to add the unique content—your stories—to the technical components and the presentation outline that you have already planned and prepared. Pick a date and location for your first session. Plan to videotape in short segments, so as not to feel rushed or become tired. Take your time. As you proceed and become comfortable with the videotape session, we guarantee that this videotape memoir creation process will prove to be fun—sometimes hard work—but always fun, rewarding, even addictive. You may, in fact, decide to turn this project into a long-term leisure activity and take weeks or months to complete it.

Get Comfortable, Get Set

Assemble your crew in the location you have chosen to start the first segment. Set the scene, position the furniture, and check and adjust the background features. Perhaps you'd be most relaxed sitting at the kitchen table with a mug of coffee in your hand. Or maybe you'd like to tell stories from your favorite easy chair. If the weather is nice, you may want to tape a session from a lawn chair or even lazing in a hammock in the back yard.

Dress comfortably in a way that will reflect your mood and personality. If you wish, you can wear different clothing in each session, just as you may wish to vary the setting.

Gather together any "show and tell" items you want to share on camera, things like clothing, sports equipment, musical instruments, toys, furniture, and other memorabilia. Items which could be shared for almost all of the topics suggested in Chapter 7 include:

- photographs
- scrapbooks
- journals or diaries
- newspaper or magazine clippings
- maps and charts
- greeting cards and invitations
- articles of clothing
- jewelry
- letters and postcards
- awards
- certificates
- paintings
- old toys; holiday cookie cutters; antique cooking equipment; tools
- your favorite old books, magazines—*Saturday Evening Post*

Accompanying many of the Chapter 7 topics are suggestions for other items you can share on camera. Use these props to embroider or supplement your words, but remember that you and your stories should remain in the spotlight. (Don't let your videotaped memoirs become solely a "show and tell" session.)

Ready the equipment: camera, tapes, tripod and other acces-

sories. Adjust the lighting and sound to appropriate levels for the setting. Frame the scene. Using the instant playback feature, make a one-minute test run. Check the results.

Eliminate possible distractions or sources of background noise. Turn off the TV or radio. Take the telephone off the hook or let your answering machine record calls silently.

Assemble your notes in your lap or nearby, where they are easily accessible and preferably out of view of the camera. Place a beverage within easy reach. Review your notes and the props that you intend to share. Settle into your setting, smile, and make a short, experimental first segment. It will feel good to get started.

Check the Results

Review the segment and declare it a "make" or a "retake." Don't be a perfectionist. You're not going for an Oscar! Most of your sessions will turn out just fine the first time. Remember, you always have the option to edit or to redo the entire segment. Laugh a little. Feel proud of yourself.

Take Two! (Sometimes)

Make adjustments in your speaking voice, your mannerisms, your script, your delivery, and re-tape, if necessary. Retakes can be fun or they can become tiresome. Again, it's your decision.

When you are satisfied with the first segment, plan the next! Select a new topic and repeat the process. Compare each segment against the previous segments. If you see that earlier segments need reworking, re-tape them. Always be sure that you achieve the results you had hoped for. If not, re-tape the segments until you are satisfied.

It won't be long before you're feeling like a "pro." You'll find that, as with all things, the more you work on your memoirs in front of the camera, the better you will get at it. Let the camera become your friend, a wonderful listener, as you record the times of your life.

Develop a videotaping schedule for additional sessions. Cover as many topics as you wish until your have shared everything you want to share.

Then review once more the contents of Chapter 7, "A Lifetime of Stories to Tell," to see if there might still be a few more tales to tell. Once you get going with your memoirs, the floodgates will open and recollections may surface that have been buried for years.

Share as many of your memories as possible. Remember, if you don't record stories about the events of your life, no one will, and knowledge of these events will disappear for all time.

A Lifetime of Stories to Tell

In this section are numerous topics covering much more than you might wish to share about the times of your life. Use the suggested topics as triggers for your own memory and as food for thought as you plan the stories of your own life.

These topics include both specific and broad areas intended to stimulate ideas for planning your videotape memoirs. They are meant to be thought-provoking, not limiting. Feel free to include, exclude, expand upon, diverge from, or let them take you in any direction that assists you with your memoirs.

Father

1. What is your father's full name? What did you call him?
2. Where and when was he born? Where did he grow up?
3. Where has he lived over the years?
4. Did he speak other languages? On what occasions?
5. What were his physical traits?
6. Describe his personality.
7. What was his educational background? What was his attitude towards education?

8. How did your parents meet, court, and marry?

9. Describe their relationship.

10. How did he earn a living? Did he enjoy his work?

11. Did he have any hired help? If so, what did they do? Where did they stay?

12. What were his pastimes or hobbies?

13. What were his special accomplishments?

14. Describe his relationship with his own parents and siblings.

15. How much time did he spend with you? Describe some pleasant or unpleasant memories of time you shared.

16. What did you like best about your father? What did you dislike about him?

17. Did he have any strange habits or idiosyncrasies? What were they?

18. Was he superstitious? About what?

19. What were some of his favorite sayings?

20. Did he ever embarrass you? Explain.

21. Did he have any noteworthy health concerns—related to the family medical history?

22. If he is still alive, where is he living? How often do you see him or talk with him on the phone?

23. If he is deceased, when did he die? What were the circumstances? Where is he buried? How did his death affect you?

24. Describe how his background and upbringing have affected your development.

25. What values and beliefs did he instill in you?

26. What did you learn from him that has helped you later in life?

27. In what ways are you like your father?
28. How are you dissimilar?
29. Share some humorous moments about your father.
30. What are some stories that others have told you about your father.

Mother

In discussing your mother, consider the same prompts and items to show on camera as for your father.

Grandparents, Great-Grandparents

See "Father" section, considering these additional prompts.

1. What did you call your grandparents when you were young?
2. What was their country of origin?
3. When, how, and why did they come to this country?
4. What stories have you heard about their lives and experiences?
5. Share any memories of special times you shared.
6. Where is your family's genealogy or "Family Tree" kept?
7. Who is the oldest relative you have known personally?

Siblings, Aunts, Uncles, Cousins, and Other Kin

1. Give the full name of the relative and define your relationship with this person.
2. What do you call him or her?

3. How does this person fit into your family tree?

4. When and where was this person born?

5. Where has he or she lived?

6. What is his or her occupation?

7. What special talents does this person have?

8. What five words would you use to describe this relative as a child? As an adult?

9. What kinds or arguments did you have? How were your disagreements resolved?

10. Describe special times you shared with this person.

11. Share some humorous or uplifting stories about him/her.

12. What kinds of interactions have you had as adults?

13. Where does this person live now?

14. How has your relationship changed over the years?

15. What are some of his/her talents or special achievements?

16. Did you share any special holidays or trips or live together at some period of time?

17. What stories has this person shared with you about himself or herself?

18. Share some stories about this person which you have heard from other family members.

19. Comment upon any other noteworthy relatives—clowns, saints, eccentrics, rustlers, senators!

Items to show on camera that relate to your relatives: Photographs, jewelry and other personal belongings, heirlooms, gifts they gave you, newspaper articles about them if any, high school or college diplomas.

Your Infancy and Early Childhood Years

1. When were you born? In what city and state?
2. What historical events were occurring in the country and the world at that time?
3. Were you born in a hospital, at home, or in another setting? Who was present?
4. What was your birth weight and length?
5. What were your hair and eye colors? Were there other physical traits you'd like to describe?
6. What is your birth order in the family?
7. What is your full name? Do you like your name?
8. Who named you and why was this name chosen for you?
9. Did you have a "pet" name? If so, how did you get it? How did you like it?
10. If you were baptized or you celebrated another infant ritual or sacrament, where and when did this ceremony take place?
11. Did you have godparents? If so, what are their names and what are their relationships to you?
12. Did you receive any special baby gifts that you still have and cherish?
13. As a baby and child, where did you sleep?
14. What were your favorite playthings?
15. When did you start talking? What were your first words?
16. When did you first walk?
17. Share some anecdotes and stories about your infancy that were told to you by members of your family.
18. Where did you live during your childhood? What are

the sights, sounds, and smells that you associate with this place?

19. Describe your neighborhood or the rural setting in which you spent your early years.

20. Describe your relationships with other members of your family.

21. What is your earliest childhood memory?

22. What was your favorite nursery rhyme? Bedtime story? Children's song?

23. What were your favorite toys and books?

24. What games did you like to play?

25. Did you attend preschool, community recreation classes or kindergarten?

26. Did a child care provider or baby-sitter care for you? If so, who was this person, where did the child care occur, and what were your feelings about this person?

27. Did you ever misbehave or get into trouble?

28. How were you disciplined at home? Elsewhere?

29. Do you remember any embarrassing or traumatic moments as a child?

30. Describe some exciting childhood adventures.

31. Did you have special friends? Who were they and why were they special?

32. Did you have an imaginary friend? What did you pretend to do together?

33. Describe your favorite pet, real or imaginary.

34. Did you have a secret hiding place? Where was it and what did you do there?

35. What were some of your childhood fears?

36. Describe some of your favorite family outings and/or vacations.

37. What were your favorite radio and television programs?
38. Describe a problem you had as a child and how you tried to solve it.
39. Describe some early childhood learning experiences.
40. At that time, what did you want to be when you grew up?
41. Share some enjoyable and/or humorous experiences you had as a child.
42. What are some anecdotes others tell about you as a child?
43. Were you or others in your family seriously ill or hospitalized during your early years?
44. Other than family members, who was especially close to you? In what way?

Items to show on camera: Baby pictures, birth certificate, baptism or other sacrament certificate, locks of hair, baby clothes and shoes, baby albums, blankets or quilts, furniture, cups, utensils, toys, games, musical instruments, books.

Elementary School Years

1. Where did you live while attending elementary school?
2. What was the name and size of the school? Where was it located?
3. Describe the school building, classrooms, and playgrounds.
4. How did you get to and from school?

5. Describe your first day of school.

6. How did you enjoy school as a child?

7. When did you learn to read? What were your first and/ or favorite books or comics?

8. What kind of student were you?

9. What are some of your playground memories?

10. Describe your favorite movies, TV or radio shows, indoor and outdoor games, toys.

11. What kinds of clothes did you wear to school? On weekends?

12. Did you have a nickname at school? How did you feel about being called this name?

13. Who was your favorite teacher and why?

14. How was classroom discipline managed in those days?

15. Were you ever called to the principal's office? Why?

16. What was your favorite subject? Why?

17. Which subject did you like least? Why?

18. What was your most difficult time during the elementary grades?

19. Who were your best friends? What did you enjoy doing together?

20. Who were your enemies? Why?

21. Share some funny stories about yourself during these years.

22. Tell about major events in your life during this time— tragic, wonderful or otherwise.

23. Did you ever do something really bad...or good? What was your punishment or reward?

24. Were you a member of any clubs or other groups?

25. Describe some memorable school programs, plays or sports activities in which you participated.

26. Did you participate in any moneymaking projects in or out of school?

27. Did you have chores to do or other responsibilities at home before and after school? What were they? How did you feel about them?

28. What school field trips or other special activities do you remember?

29. Did you win any awards or honors during these years? What special efforts or talents led to these awards?

30. Did your family think that your education was important?

31. Describe your parents' approach to family discipline and how they trained you.

31. How did you and your siblings get along? Why do you feel your relationships with your siblings unfolded as they did?

33. Did anyone tease or bully you? If so, how did you handle the situation?

34. What kinds of things did you like to do when it snowed? When it was rainy outside?

35. Were you in a frightful, terrible storm during these years? Did your home have a storm cellar?

36. Do you have memories of losing your baby teeth?

37. How long did you believe in the Tooth Fairy and Santa Claus?

38. How did you feel about going to the doctor? Did you have any health concerns?

39. Who did the cooking in your home? What kinds of meals were standard? Did you help with the cooking or cleanup? What was your favorite home-cooked meal? What kinds of food did you despise?

40. Were you and your family active in any community activities such as church or synagogue, cultural events, fairs?
41. What did you do during summer vacations?
42. Did you become a collector during these years? What did you like to collect?
43. Who were your heroes? Why?
44. Which creative talents did you explore and cultivate?
45. Did you attend any summer camps or summer programs? Describe your experiences.
46. Were you involved in sports or athletics as a participant and/or a fan?
47. Describe an elementary school days' experience that taught you a lifelong lesson.

Items to show on camera: Photos of yourself and your school, books, notebooks, backpacks, lunch box, pencil box, report cards, awards, samples of school work or art, school uniforms.

The Teen Years

1. Which junior high or middle school(s) and high school(s) did you attend? Describe them.
2. Where did you live during this time? What were your home and school neighborhoods like? If your family moved frequently during these years, how did that affect you?
3. What was your transportation to and from school?
4. What was your attitude towards school? What kinds of grades did you make?

5. What did you look like as a teenager? Describe yourself. Did you wear glasses or braces?

6. What were the current fads in clothing and hair styles? Did you adopt or reject them?

7. Describe the rules and expectations you lived with, for instance, a school dress code or a curfew.

8. What were the "in" teen expressions in those days?

9. Who were your favorite teachers? Why? What were your favorite classes? Why?

10. Which classes and teachers did you not like? Why?

11. Describe your greatest problem in each school that you attended and how you solved it.

12. What did your teachers think of you?

13. What did you do for fun? What kinds of music and dances were popular?

14. What was the cost of a bus ride, a school lunch, a movie, a record, a soda, or a hamburger?

15. What special interests or hobbies did you have? Were you in clubs or organizations? Why did you choose to join these clubs or organizations?

16. What were your favorite foods, television and radio shows, and movies?

17. How important were books to you? Which writers and literary works influenced you most?

18. Share some of your negative memories—difficult/intense times, embarrassments, insecurities.

19. Did anyone ever tease or bully you? If so, how did you handle the situation?

20. Were you jealous or envious of others? Were you subjected to discrimination? Explain.

21. Were you popular? Shy? A loner? A leader? A follower? Rebellious? Conservative?

22. Describe your family life during these years. Were you close or estranged?

23. What were your chores and responsibilities at home— cooking, cleaning, child care, doing laundry, yard work?

24. Who were your best friends? Why? Have you kept in touch with each other? How?

25. Describe your part-time jobs and moneymaking projects.

26. What did you do with your money? Did you save money? What were your favorite purchases? Did you have money worries? Explain, using a story as an example.

27. Did you have any memorable school trips?

28. How did you spend your summer vacations?

29. Did you receive any awards, honors, or special recognition? Were there other big moments?

30. In what ways were you involved with art, music or drama lessons or performances?

31. If you participated in sports, describe what, why, and how well you played. Did you incur injuries or have traumatic experiences?

32. What community/world events influenced your thinking and development during these years?

33. Who were your teenage idols or heroes?

34. Who were your anchors? Did you have enemies or nemeses?

35. Share an enjoyable or humorous experience from these years.

36. Describe some lessons you learned and how they helped you later.

37. How were you like other teens? How were you different?

38. What did you do as a teenager that you wouldn't want your children/grandchildren to do? Why do you feel the way you do about this now?

39. If you got into trouble at school or with your parents, how were you disciplined?

40. When and how did you learn "the facts of life"?

41. How did you feel about leaving childhood behind and becoming an adolescent?

42. Did you experiment with or get involved with smoking, drinking, or drugs? Did this create problems?

43. Describe your early adventures with dating. When did you start? Whom did you date? Where did you go and what did you do? Tell about a date you'll never forget.

44. What were acceptable behaviors for teenage dating then?

45. If you participated in special events like homecoming and the prom, describe them.

46. Were you apprehensive about approaching the end of your high school days?

47. When did you graduate? Describe any graduation parties with friends and family.

48. If you did not graduate, what happened?

49. Do you think high school prepared you well for the future?

50. Were you able to pursue your post-high school dreams and goals? Why or why not?

51. If you have ever attended a high school class reunion, how did you enjoy it?

Items to show on camera: Photos of yourself, your school, your friends, your car; class jewelry, sports gear, school uniforms, letter jackets, pennants, records, report cards, yearbooks, awards.

Vocational School—College Years

1. Where and when did you go to this school? What were the admissions procedures?
2. Why did you choose to attend this school?
3. What was the tuition and how was it paid for?
4. Where did you live while attending vocational school/ college? Did you have a roommate?
5. Did you cook in or eat out? What were your favorite foods?
6. Were you a member of a sorority, fraternity or other social group?
7. What was your attitude towards getting a higher education?
8. Describe your first day on campus and how you felt about being there.
9. Share memories of your alma mater—logo, motto, song, sports team names, mascots.
10. Who was your favorite instructor? Why? What were your favorite courses? Why?
11. Which studies or requirements did not apply to your interests and needs?

12. What were your major and minor areas of study? Did you change majors? If you could do it all over and pursue another field, what would it be? Why would you make this change?

13. What kind of student were you—serious, playful, or somewhere in between?

14. How did you handle the freedom and need for self-discipline?

15. How much did you study? What were your grades?

16. Describe any jobs you had during this time, including summer jobs. What did you get paid? How did you like them? What did you learn from them?

17. What were your favorite kinds of entertainment and recreation? How much time did you allow for fun? Where did you like to hang out?

18. In which special activities, interests, clubs or organizations did you participate? What led you to become involved in these?

19. Describe your social life. Did you date a lot? Were you involved in any serious relationships?

20. What was your basic means of transportation—walking, bike, car, bus, hitching a ride?

21. What did you look like at this time—clothing, hair, physical shape, and condition?

22. What negative experiences or traumas did you have to deal with?

23. What were the burning political or social issues that affected you during these years?

24. Did you get involved with any confrontations, demonstrations, sit-ins, strikes, or rallies? What motivated this involvement?

25. What ties did you have with your family at this time? In what ways were they supportive—or not?

26. Did you have any travel experiences or exciting adventures while in college?

27. If you received any special recognition, awards or honors, describe them.

28. Share some poignant anecdotes—happy, sad, frustrating, exhilarating—from these days.

29. Were you worried about finding employment after graduation?

30. Describe your graduation ceremony and celebration.

31. If you did not graduate, what happened?

32. What did you want to do after this period of your life? Were you able to carry out your plans?

33. Did this experience in higher education prepare you well for the future?

34. At this point in your life, how did you define success?

35. What were your life goals—attaining wisdom, fame, wealth, happiness?

36. How has having this college education or vocational training impacted your career and life decisions?

37. What advice do you have for people who are considering higher education options?

38. Have you been active in alumni associations and reunions? Why or why not?

Items to show on camera: Photos of yourself and your school, school pins, rings, letter jackets, programs, musical instruments, sports equipment, pennants, yearbooks.

Military Service

If you were not in the military, you may use these questions to describe how the military experiences of someone who was near and dear to you impacted your life.

1. What were your years of military service? In which branch did you serve?
2. Was your country at war then? If so, which war? What were you doing when the war began? When it ended?
3. Did you enlist or were you drafted into the service? If you enlisted, what were your reasons for doing so?
4. Describe your induction into the service. How did your family and friends react?
5. Did you ever consider being a conscientious objector? Did you know anyone who was?
6. At which rank did you enter and at which rank were you discharged?
7. Where was your basic training? Share your reactions and adjustment to military codes, regulations, training techniques, and discipline.
8. What weapons, equipment, and programs were in use during these times? Which ones did you use?
9. Where were your duty stations and what work did you perform there?
10. Describe some of your boring, exciting, and terrifying experiences at these locations.
11. Were you ever in combat? When and where? What were the circumstances?
12. Were you ever in a military accident or wounded?
13. What kind of medical help and treatment was avail-

able? Do you still feel the effects of your military traumas, physical and mental?

14. Did you receive any medals, ribbons or special recognition for your military service? What was the basis for this honor?

15. Where did you go and what did you do on furloughs?

16. What did your parents, your spouse or significant other, and your siblings do during this time? Did they have to make major adjustments in their own lives because you were in the service?

17. How often did you receive mail from home or get to see your family? Were you homesick?

18. How were you affected by military rationing?

19. Did your romantic relationships survive these years? Why or why not?

20. Did you develop some special friendships in the service? Do you still keep in touch with these friends? How?

21. Describe your discharge from military service and your reunion with loved ones.

22. In what ways did the military make good use of your abilities?

23. Did your military experience help you develop hidden traits or talents?

24. Did you ever consider making a career of military service? Why or why not?

25. How were you changed by your military experience?

26. Was it difficult for you to adjust to civilian life again?

27. If you could change anything about these years, what would it be?

28. What would be your advice to people considering military service or careers today?

29. Do you participate in military reunions, parades or other veteran's activities?

> ***Items to show on camera:*** Photos of yourself and your various stations, uniforms, ribbons, medals, service papers, foreign currency, souvenirs.

Work Experiences—Career

If you worked occupationally outside of the home, either for yourself or for others, consider the following:

1. What was your first paid adult work experience? Who was your employer?
2. How did you get the job—explain the process from researching leads and ads to the application and hiring processes.
3. Describe your workplace. How long were you employed there?
4. How were you paid—hourly or salaried? What were your hours?
5. What were your responsibilities?
6. Would you characterize your work as physical, mental, or a combination of both?
7. What kind of training did you receive? Were you an apprentice or did you have a mentor?
8. Describe the working conditions. How did you feel about doing this kind of work? Were you good at this job?
9. How did you get along with your boss and your colleagues?
10. Describe a typical day on the job and some of the atypical situations you had to cope with.

11. How long did you stay with this job? Why did you leave?

12. How did this job fit into your career path?

(Repeat 1-12 for other jobs.)

13. Which was your favorite job? Why?

14. Which job did you like least? Why?

15. Did your parents or significant other influence your job choices? In what ways?

16. Have you ever been self-employed? What were the related advantages and disadvantages?

17. Have you ever been a supervisor? How did you feel about that role?

18. Tell about the most challenging job assignment or the most demanding position you have held.

19. What equipment and technologies have you used in your work? How have you adjusted to the age of computers?

20. What have been some of your job-related worries and concerns?

21. Describe your most rewarding job experience.

22. Share some funny stories about your work.

23. Have you ever worked in a dangerous profession? Were you ever injured on the job?

24. Describe your most difficult career decision.

25. Were you ever forced to leave a job you wanted to keep? Why?

26. In what unions or professional organizations were you a member or leader?

27. Have you ever mentored anyone in your field? How did you help this person gain skills?

28. What personal qualities helped you succeed in your career?

29. How much of your success do you attribute to chance, hard work, having connections, or gender considerations?

30. Describe a particular work achievement or accomplishment that gives you pride.

31. What career obstacles have you overcome?

32. Were you ever involved in a strike? Ever walk a picket line? Explain the outcome.

33. Have you ever experienced job discrimination?

34. Which personal traits may have negatively affected your career advancement?

35. Have your jobs ever interfered with your marriage or family responsibilities? If so, did you make adjustments or rearrange priorities?

36. Are you a workaholic or do you try to balance varied interests and aspects of your life?

37. What is the hardest lesson you ever learned on the job?

38. If you have retired, why and when did you do so? How are you adjusting to retirement?

39. If you could start all over, what career would you want to pursue? Why?

40. What new kind of work would you like to try at this time in your life?

41. What advice can you give young people that might help them succeed in their career goals?

Items to show on camera: Organization or company logos, uniforms, name tags, newsletters, awards, letters of recognition, contracts, pay statements, tools of the trade.

Homemaking

1. What are your various household responsibilities?

2. Which is your favorite?

3. What do you like least about being a homemaker?

4. What are your special homemaking skills and expertise?

5. What are your weak areas and how have you improved on these over the years?

6. When and how did you learn your homemaking skills?

7. What are some humorous tales about your homemaking experiences?

8. Have there been frightening moments or crises to deal with?

9. Are you a good cook? What are your own and your family's favorite dishes?

10. What has been the most challenging or difficult aspect of household management for you?

11. Have you been able to carve personal time out of homemaking so that you can explore your own interests and hobbies?

12. What community, church or synagogue, cultural, recreational activities do you enjoy?

13. How have you managed to find a balance for all the elements of your life?

14. Describe your typical weekday routine? How is this routine different on weekends and holidays?

15. How do you manage to keep the household running when you are ill or traveling?

16. Tell about a homemaking accomplishment that gives you great pride.

17. Why did you choose to be a homemaker? How do you feel now about this choice?
18. In what ways have you been "paid" for your services?
19. If you had chosen to work outside of the home, what jobs or career would you have pursued?
20. What advice would you give to those who are considering being full-time homemakers?

Volunteer Experience

1. What was your earliest volunteer work experience?
2. Where and when did you volunteer? How old were you?
3. Describe your schedule. What were your hours?
4. Why did you choose to volunteer your services rather than seek paid employment?
5. What factors did you consider before becoming a volunteer?
6. Describe your responsibilities and duties.
7. How did others benefit from the services you provided?
8. What were your coworkers like? Did you form friendships with other volunteers?
9. What nonmonetary rewards did you gain from this experience? Why do you consider this time well-spent?
10. How long did you do work there? Why did you stop?
11. What are some of the high points and moving moments of your volunteer work?
12. Was there a volunteer experience you did not enjoy? Why?
13. Would you recommend this kind of work to others? Why?
14. Have you ever served in a leadership position for a

private/nonprofit organization? If so, what were your responsibilities?

15. For which other organizations would you like to volunteer your services in the future?

16. Which are your favorite charities? Why? In what ways have you helped these organizations?

Fabulous "Firsts"

What are your recollections of some of these "firsts" in your life?

I remember when I first got:

1. a toy truck or wagon
2. a doll
3. a ball
4. a spanking
5. a favorite indoor/outdoor game
6. a broken bone
7. glasses
8. sports equipment
9. a musical instrument/music lessons
10. an allowance
11. a bicycle
12. a wallet
13. braces
14. lipstick
15. high heels
16. valuable jewelry
17. a car
18. an apartment
19. a television set

20. the family car
21. a camera
22. a house
23. a dishwasher
24. a boat
25. a microwave oven
26. a paid vacation
27. a prize in a contest
28. a computer
29. a video camera
30. life insurance
31. other "firsts"

I remember when I first learned how to:
1. skip
2. ride a tricycle or a bicycle
3. whistle
4. jump rope
5. roller skate
6. ice skate
7. dance
8. play an instrument
9. ride a horse
10. use a lawnmower
11. ski
12. use a hula hoop
13. use a checkbook
14. drive a car
15. appreciate books, movies, etc.
16. change a tire
17. cook a meal

18. sew
19. use a credit card
20. manage a budget
21. paint a picture
22. other "first" learning experiences.

> ***Items to show on camera:*** Any of the many potentially relevant photos or objects which relate to "firsts."

Romantic Interests

1. Share stories about your childhood girlfriends or boyfriends.
2. What was your first experience with young love? How old were you? How did you know that you had a crush or were in love?
3. How did you meet your first love? What did you like to do together?
4. Describe your first date. How did you and your date meet? How old were you? Where did you go and what did you do?
5. What were your early impressions of this person and how did you enjoy your time together?
6. How long did this relationship last?
7. Who were your teenage boyfriends/girlfriends?
8. How did your parents and friends react to the people you dated?
9. Who was the object of your first big teenage crush? Were your feelings reciprocated? Why or why not?
10. Did you ever have a blind date? What happened?

11. Did you ever double date? With whom?

12. What was your favorite kind of date? Where did you like to go? What did you like to do?

13. Were you openly affectionate with your dates? How did you demonstrate your affection?

14. Of all the people you dated, who were your favorites? Why?

15. Did you break any hearts? Was your heart ever broken?

16. Whom did you date for the longest period of time?

17. Did you ever go steady? With whom, why, how long?

18. Describe some of the good and bad experiences of your dating.

19. What was your family's attitude about your dating?

20. Which of your date partners did your family like best? Why?

21. Which date(s) did they object to? Why?

22. Share some embarrassing or humorous memories from your dating years.

23. Describe some of the gifts you gave or received while dating.

24. Were you ever engaged? Did you or did you not decide that this was someone you wanted to marry?

25. Explain your feelings. When, how and why did you decide to marry?

26. What were the qualities that attracted you to each other?

27. Describe the proposal and both your own and your partner's reaction to it.

28. Did you receive an engagement ring or other pre-wedding present?

29. What was your family's reaction to your announcement of impending marriage?

30. Was a formal announcement made? Did you have an engagement party?

31. How long were you engaged? Describe your continuing courtship and preparations for marriage.

32. Did this engagement lead to marriage? Why or why not? (See "Marriage" and "The Single Life" sections.)

33. Have you kept in touch with any former romantic interests? What is your relationship with this person or persons now?

34. Do you still carry a torch for a former boyfriend or girlfriend? Explain.

35. What is this thing called love?

36. What is your favorite love song, movie, book, or poem?

37. Who have been the great romantic loves of your life?

Items to show on camera: Dating and courtship relics—photos, scarves, pins, jackets, engagement ring or other gifts.

Marriage—Relationship with Your Significant Other

1. What is the full name of your spouse or significant other?

2. Where and when was this person born?

3. Where did he or she attend school?

4. What was this person's life like before meeting you?

5. How and when did you meet?

6. What was your first reaction to the person? Did you

change your mind about him or her as you got better acquainted?

7. Describe your first date together—when, where, what you did, your initial reactions.

8. When and how did you fall in love?

9. What did you have in common? In what ways were you different? What did you enjoy doing together?

10. Were there other love interests in your life then? How did you sort out these relationships?

11. If you became engaged, describe that time in your relationship. (See "Romantic Interests" section.)

12. If you did not choose to marry, but committed yourselves to each other, explain why you chose that arrangement.

13. Why did you decide to wed or commit to this person?

14. Describe any wedding showers or parties.

15. When and where did your wedding take place? Why did you choose this time and site?

16. Who performed the ritual? Who was in the wedding party? Who attended the ceremony?

17. What did you and your attendants wear?

18. Describe the ceremony. Did everything go as planned or were there glitches and surprises?

19. Was your wedding audiotaped or videotaped? Where is the tape kept? (Perhaps you can use a portion of any tapes made of your wedding in your videotape memoirs.)

20. Share the other details of your wedding day—details about the food, music, flowers, weather, reception.

21. Were you given a dowry or a hope chest or some other special gift?

22. How was your spouse welcomed into your family? How does he or she relate to members of your family?

23. When and how did you meet your spouse's family? How do you relate to your in-laws? Did/do you spend time with them often?

24. Describe your honeymoon—where, why you chose that locale, how long, how you enjoyed it.

25. Where did you live after you returned from your honeymoon?

26. Share a story about being newlyweds.

27. What were some of the adjustments you each had to make to marriage?

28. How did you divide your household responsibilities? What roles did each of you play?

29. Did each of you work outside of the home? If so, what were your jobs?

30. How did you design and manage your first budget?

31. Describe how you made a good team and complemented each other.

32. What activities did you enjoy together?

33. What activities did you continue to enjoy separately?

34. Have there been bumps in the marriage road? Explain these and how you worked to overcome them.

35. How did you cope with surprises and unwelcome changes?

36. How often did you quarrel? How did you resolve your differences?

37. What compromises have you made to maintain your marriage?

38. Describe a crisis in your marriage and how you weathered it.

39. What plans, goals, and dreams have you shared? Which of these have materialized?

40. Did you agree on when to start a family and how many children you wanted?

41. Describe some of your most memorable anniversaries.

42. How long have you been married?

43. What is the best thing about your marriage?

44. How has your relationship with this person grown over the years?

45. What would your spouse be surprised to find out about you today?

46. If this relationship has dissolved, explain what happened. (See "Divorce" section.)

47. If your spouse or significant other has died, explain the circumstances. (See "Life as a Widow/ Widower" section.)

Items to share on camera: Wedding photos, audiotapes, wedding dress, marriage certificate.

Separation—Divorce

1. How long were you together before you separated or divorced?

2. What were the good aspects of your marriage before the relationship dissolved?

3 Why did you choose to go your separate ways? Was this by mutual agreement or not?

4. Did you live separately for a time before divorcing?

5. What was the most difficult part of preparing for the divorce?

6. Were you and your spouse friendly or bitter during the divorce process?

7. When did you get divorced? How did you feel after the divorce was finalized?

8. How did your family and friends react to the news?

9. If you had young children, what were the custody and visitation arrangements?

10. How did your children react to your separation/divorce? If they were upset, how did you help them cope?

11. When did your children come to accept your divorce and the new arrangements?

12. What did you do to adjust to your new situation? Did you keep your same home, your same job? Did you maintain certain friends and activities? Did you move and seek a fresh start?

13. How did you feel about yourself in the months after your divorce?

14. What are some of the advantages and disadvantages to being single again?

15. What is your relationship with your former spouse now?

16. What did you learn from this divorce?

17. Would you consider remarrying? Why or why not?

18. If you married again, describe what motivated you to do so.

19. Did your new spouse bring children to your marriage? If so, how have you managed to combine the components of your new family?

20. What advice would you give to those who are considering a divorce?

The Single Life

1. What circumstances led you to the single life?
2. Describe some of your romantic experiences.
3. Why did these relationships not lead to marriage?
4. Have you ever wanted to marry? Who? When? Why did this not work out?
5. What qualities would you look for in a spouse or significant other?
6. How do you think marrying would impact your single lifestyle in positive and/or negative ways?
7. What are your reasons for remaining single?
8. What are some disadvantages of the single life?
9. Describe your social life as a single person. What do you do for fun with others? What are your favorite kinds of social interactions?
10. Do you have a roommate? Why or why not?
11. How often do you get together with friends? Family? Colleagues? Strangers?
12. Do you relish time alone? What do you like to do when you are alone?
13. Have you ever considered becoming a single parent? Why or why not?

Life as a Widow or Widower

1. How many years were you married before your spouse died?

2. What was your spouse's cause of death? Was it sudden or expected?

3. How old was your spouse when he or she died?

4. How did you deal with this loss?

5. What did people say and do that helped you most through this difficult time?

6. What was said or done that made you feel uncomfortable or sad?

7. What processes did you use to help yourself through this period?

8. Describe your grieving process.

9. What business preparations do you think would have helped make this time easier for a surviving spouse?

10. Had previous preparations been made for the funeral and burial of your spouse?

11. Describe the funeral services and resting place.

12. What are some positive things that you did for yourself after losing your spouse?

13. Would you consider marrying again? Why or why not?

14. Did you become romantically involved with another person after the death of your spouse?

Children

1. When did you first realize that you wanted to have a child/children?

(Repeat the following for each child.)

2. How did you and your partner react to the news that this baby was coming? Was the pregnancy planned?

3. What preparations did you make?

4. What was the mother's physical condition during pregnancy?

5. Did you have training in birthing techniques?

6. Were any baby showers given? By whom?

7. How did the birth of this baby change your life?

8. What is your child's full name? Why did you choose this name?

9. Where and when was the baby born? What were the circumstances of the birth?

10. How quickly did you bond with this child?

11. What were his or her cute behaviors or first words?

12. Describe your child's physical traits—as an infant, as a child, as a teen, as an adult.

13. How would you describe his or her early personality?

14. What were his or her talents and special accomplishments?

15. Share some stories about his/her early years.

16. What were the teen years like for this child?

17. What schools did he or she attend? Where was your family living at those times?

18. Describe some of the difficult times for this child and how he or she met the challenges.

19. What three words best describe this child's adult personality?

20. Where does this child live now?

21. What kind of work does he or she do?

22. Has this child married? If so, how did he or she meet the spouse?

23. Where and when were they wed?

24. Have you enjoyed being an "in-law"?

25. Does this child have children? If so, what are their full names?

26. How much contact do you have now? Describe your present relationship.

27. Describe the proudest moment you had with this child.
28. What was the saddest experience you had with him or her?
29. What have you learned from your child?
30. What advice or thanks would you like to give him or her?

Items to show on camera: Photographs of each child at different ages, school work, sports trophies, art work, report cards.

Adoption

If you were an adopted child:
1. When were you adopted?
2. At what age were you adopted?
3. What were the circumstances of your adoption?
4. Do you know the names of your biological parents?
5. Do you know why your biological parents offered you for adoption?
6. Why did your adoptive parents want to adopt you?
7. How did you find out that you were adopted?
8. How did you feel when you learned that you were adopted?
9. If you have met your biological parents, describe that first meeting.
10. If you maintain contact with your biological parents, what is your relationship now?
11. If you do not know who your biological parents are, would you like to know their identities?
12. Would you like to meet them? Why or why not?

13. What are your feelings for your adoptive parents?

14. How have they treated you? What kinds of nurturing and support have they given you?

15. Do you have biological or adoptive siblings?

16. If so, what is your relationship with them?

If you have adopted a child or children:

1. Why did you want to adopt a child?

2. Was your spouse agreeable to adoption?

3. What did your friends and family think of the idea?

4. How did you research adoption options?

5. Did you request a child with certain characteristics from a specific background?

6. Were you willing to adopt any available child?

7. Describe the application, interview, and selection process which rendered you eligible as an adoptive parent.

8. How did you feel about being evaluated as a prospective parent?

9. What agency or method did you use? Were there any problems or disappointments?

10. What were the advantages and disadvantages of the adoption system you used?

11. How did you select this child?

12. When did you first have contact with the child?

13. How long did it take for you to complete the adoption process and gain custody?

14. Do you know who the biological parents of the child are? Have you met?

15. Does your adopted child know that he or she is adopted?

16. Has your adopted child ever met the biological parents? How did you or how would you feel about such a meeting?

17. Do you have any biological children?

18. How has your adopted child blended into your family?

19. If you have adopted more than one child, what were your reasons?

20. What have been the joys and problems associated with adoption?

Parenting

1. Did you raise your child as you were raised?

2. How was your approach to parenting different from that of your parents?

3. Did both parents work outside of your home when your child was young? If so, who provided child care?

4. How much did your partner share in parenting responsibilities?

5. How did you manage to meet the demands of your family, work, and community?

6. What have you liked most about being a parent? Describe a rewarding moment.

7. Did you let your child believe in the Tooth Fairy and Santa Claus? For how long?

8. What were some of your frightening moments as a parent?

9. Which have been the most challenging parenting stages for you—when your child was young, a teenager, an adult?

10. How did you cope with some of the difficult aspects of raising children—like sibling rivalry and bickering?

11. Describe the household chores you assigned to your child and how they were performed.

12. Did you give your child an allowance or pay him or her to perform chores?

13. Did you monitor how he or she spent this money?

14. Did your child try to manipulate you? How did you handle this?

15. What did your child do that consistently made you angry?

16. What did he or she do that pleased you?

17. What were some of the effective ways you disciplined your children?

18. How were/are your children different? How were/are they alike?

19. Have you treated them the same or differently? How and why?

20. What did you hope or think your child might grow up to be? Did your wishes or predictions materialize?

21. If your children are grown and out of the house, have your parenting concerns and responsibilities decreased?

22. If you are a single parent, what have been your special joys and challenges?

23. Assess yourself as a parent. If you could go back in time, what would you change about your parenting skills?

24. What advice would you offer parents about parenting their own children?

Family Life

1. Describe your notion of ideal family life. How has this notion changed over the years?
2. Did you and your partner have the same or different views about what constituted a good family life?
3. How did your real family life measure up to your ideals and expectations?
4. What were some of your family rules and regulations?
5. What shared activities did you enjoy as a family?
6. Who are some people you consider as family who are not relatives?
7. What roles, traditional or nontraditional, did members of your family assume?
8. How much time did you spend together as a family on a typical weekday? On weekends?
9. Explain how the concepts of "unconditional love" and "tough love" have or have not been a part of your family's dynamics.
10. What outside events have impacted the functioning of your family?
11. What special occasions did/do you celebrate together as a family—birthdays, anniversaries, religious observances?
12. Do you ever have family reunions? If so, describe them.
13. Has anyone developed your family's genealogy? If so, where is it kept?
14. Are you interested in contributing information to your family's genealogical research? Consider contributions you could make to this project.
15. Describe your family life as an unfolding drama—comedy, farce, melodrama, romance, tragedy, or an olio.

> ***Items to show on camera:*** A family portrait, pictures of family holiday celebrations, family Bible, family tree diagram, photos of the homes in which you have lived.

Home Sweet Home

(Repeat for various homes or dwellings.)

1. What was the address and/or location of this home. When did you live there?
2. Describe this home's exterior, including its color and design.
3. What was the setting for this home—yard, trees, flowers, neighborhood?
4. Who lived in this home with you?
5. Describe some of the rooms in this home—colors, decor, furnishings, feelings.
6. Which room was your favorite? Why?
7. What were some special features of this home?
8. How was your home kept warm in the winter and cool in the summer?
9. Imagine that you are looking out from a window on each side of your home. What do you see?
10. What sounds do you hear? Are there special odors or aromas in the air?
11. Share some stories about your life in this home— funny, sad, interesting memories.
12. Which neighbors do you remember and what are your recollections about them?
13. What did you like best about this home? What did you like least?

14. What kind of entertainments were shared and enjoyed in this home?
15. Describe any improvements or renovations you made for this home.
16. Why did you leave this home?
17. Have you ever had a vacation home? If so, describe it.
18. Of all your homes, which was your favorite? Why?
19. What comes to your mind when you hear the song or phrase "Home Sweet Home"?
20. If you could choose any location for your next home, where would it be?

Items to show on camera: Sales advertisements, deeds, pictures of the home, favorite furnishings.

Birthdays

Describe your favorite birthdays, relying on your own recollections or those of others.

1. Which childhood birthday celebration(s) can you recall? Why do these particular birthdays stand out in your memory?
2. How old were you on these occasions?
3. Where was the birthday party held?
4. Who was there?
5. Describe the cake and other food.
6. What decorations and party favors were used?
7. What birthday games did you play?
8. Was there any special entertainment that you recall?
9. How did you feel during and after the party?

(Repeat for the various times in your life—as an adolescent, as an adult, as a senior.)

10. Were you ever given a surprise birthday party? Was it really a surprise or did you know about it in advance? How did you feel about it?

11. What was the best birthday gift you ever received? Explain.

11. Which was your favorite birthday celebration? Why?

13. Was there a birthday that you dreaded? Why?

14. Did you have a mid-life birthday crisis? Explain how you dealt with it.

15. How old are you now and how old do you feel and/or act?

16. How would you like to celebrate your next birthday or future birthdays?

17. Name some gifts you would like to receive.

18. How many more birthdays would you like to have?

Items to show on camera: Birthday party photos, invitations, cards, favors, gifts, decorations, memorabilia.

Holidays—Traditions

1. Describe your typical or favorite New Year's Eve or Day celebration as an adolescent and/or adult.

2. How do you observe Martin Luther King, Jr. Day, the Chinese New Year, St. Patrick's Day?

3. Do you have any poignant Valentine's Day memories?

4. April Fool's Day may trigger recollections of tricks you played or of tricks played on you. If so, share some of them.

5. If the Lenten period, Easter or Passover has been a special time for you, explain why.

6. What are your May Day memories? Did you give or receive May baskets?

7. Do you celebrate Cinco de Mayo? How?

8. Describe a memorable Mother's Day or Father's Day.

9. How do/did you celebrate Memorial Day? Did you and/or your family decorate grave sites?

10. What are some of your exciting Fourth of July experiences?

11. Do long, end-of-summer Labor Day weekends evoke memories?

12. What did you and your family do on Halloween? What were your favorite costumes? Do you recall Halloween parties, bobbing for apples, guessing who was behind the mask, and so on?

13. Describe your family's Thanksgiving Day celebration and the meal that accompanied it.

14. What Christmas or Hanukkah stories would you like to share?

15. Are there other holidays that you or your family traditionally celebrate?

16. Which holiday has been your favorite over the years? Why?

17. What holidays do you celebrate now? Where and how?

18. What traditions, family or holiday, have you and your family observed over the year—a Sunday meal together, cutting your own Christmas tree, carving pumpkins and making pie on Thanksgiving?

19. Have you videotaped any important family traditions or gatherings? If so, where are the tapes stored? (Per-

haps you can use portions of these tapes in your video memoirs.)

Items to show on camera: Holiday photos, Christmas cards, invitations, decorations, gifts, costumes.

Family Reunions

1. Has your family ever had a reunion? If so, how often? Who planned it? Do you like attending larger family gatherings?
2. Was the reunion successful? Was it emotional, embarrassing, loving, nostalgic?
3. Describe the reunion decorations, entertainment, program, and special activities.
4. Were there displays of photographs, heirlooms, and memorabilia?
5. What kind of food was served?
6. How many attended? Describe some of your interactions with others.
7. When was the last time you had seen some of these people?
8. Were there any surprises?
9. Why did you choose to attend? What were your expectations? How were they met?
10. What was your favorite part of this event?

Vacations—Travel—Retreats

1. Were vacations an important part of your own and/or your family's life?

2. Think of a favorite vacation that you took during your lifetime. Where did you go? When?

3. Why did you choose this vacation spot?

4. Describe the planning process for this trip.

5. Who traveled with you on this vacation?

6. What was your means of transportation?

7. What was your travel time and itinerary?

8. What are some of your interesting memories about this vacation?

9. What learning experiences did you have?

10. Did your plans work out? What problems did you encounter? Explain.

11. What were some of the more enjoyable aspects of this trip?

(Repeat the above for other vacations.)

12. Did you ever return to this vacation spot? Why or why not?

13. Have you had any special "Spring Break" experiences?

14. Have you ever gone on a personal retreat? Describe this experience.

15. Do you have memorable camping stories to share?

16. Have you ever gone on a vacation in a recreational vehicle? If so, share these experiences.

17. Have you ever taken a cruise? If so, describe what you liked and did not like about it.

18. Did you ever go on a houseboat for a getaway? If so, how did you enjoy that experience?

19. Have you ever stayed at home for a vacation? In what ways was this rewarding? Explain.

20. Have you and your spouse or significant other ever

chosen to take separate vacations? How did you formulate this agreement?

21. If you have children, do you always take them with you on vacations?
22. Describe your best family vacation.
23. Summarize your travels in this country or abroad.
24. Where would you like to vacation next? Why?

Items to show on camera: Photos, maps, passports, souvenirs, collections, travel books, and/or scrapbooks, journals.

Pets and other Animals

Talk about the pets you have owned, loved, cried over, and cursed from your childhood to the present. (Repeat for each pet you wish to talk about.)

1. What was the name of your pet?
2. How did it get its name? Was the name an appropriate or descriptive one?
3. What kind of pet was it? Describe its appearance.
4. Did this pet have papers or credentials?
5. How did you acquire the pet?
6. Why did you choose this pet?
7. What were your pet's favorite foods and treats?
8. Where did it like to sleep?
9. Describe any problems that occurred with this pet.
10. What was your most embarrassing moment with this pet?

11. What were its favorite toys?

12. How did you play with your pet?

13. How smart was your pet?

14. Did you "talk" with your pet? Describe how you communicated with each other.

15. How did you or someone else train your pet?

16. Did your pet need veterinary care often? Why?

17. Did you ever enter your pet in a show or competition? What happened?

18. Describe your pet's personality.

19. What learning experiences did your pet create for you? What other joys did your pet give to you?

20. Share some interesting and/or humorous stories about your pet.

21. Did this pet reproduce? How often?

22. Did you breed this pet for sales purposes?

23. How long did you have this pet? How traumatic was this pet's death?

24. How did other members of your family get along with this pet?

25. Have you ever brought home a stray or adopted a pet from a shelter?

26. Which was your favorite pet? Why?

27. Have you ever endangered yourself to help a pet or wild animal?

28. What happened to it?

29. Did you belong to a 4-H club or raise animals?

30. Have you ever collected insects or reptiles or birds?

31. Describe an encounter you had with an animal in the wild.

32. Do you feed wildlife? What kinds? Describe the rewards this effort brings you.

33. Are you an animal protector or activist? Explain.
34. How well do you relate to animals in general? Explain.

Items to show on camera: Pet photos, certificates, toys, cage, bed, collar, tags.

Health

1. What childhood and/or adolescent illnesses and diseases did you have?
2. How were these illnesses and diseases treated?
3. Explain your feelings about doctor visits during these years. Did your doctor ever make house calls?
4. Were you ever hospitalized as a child or adolescent? What for? For how long?
5. How did you react to being hospitalized? What were your thoughts, your fears, at this time?
6. Did you have any broken bones or other accidental injuries during your childhood or adolescence?
7. Describe any major physical health problems and/or surgeries that you have had as an adult.
8. What is your blood type? (Believe it or not, this is an interesting and sometimes important thing to record in a memoir or elsewhere.)
9. Have you been injured during your adult years? If so, describe what happened and how you were treated and healed.
10. Are you or have you ever been on a special diet?
11. Describe your current and past exercise patterns and activities.

12. Besides exercise, what other things do you do to keep yourself healthy and fit?

13. Have you ever suffered from depression? If so, describe the situation and your treatment?

14. Who are your current and past health care providers and doctors? What was the nature of your relationships with these individuals?

15. What medications do you take regularly and why? Where are they kept?

16. Where do you keep your health records?

17. Have you ever used nontraditional healing methods? If so, which ones and what were their effects?

18. Has anyone close to you had a serious health problem that has affected your lifestyle?

19. If you could wave a magic wand and fix some aspect of your health, what would it be?

20. What are your personal recommendations for living a long, happy, and healthy life?

Items to show on camera: Health records, insurance and doctors' cards, exercise equipment.

Creative Endeavors

1. What is your favorite creative activity?

2. Have you had lessons to acquire a creative skill? Describe these lessons and their effect on your creative endeavors.

3. Who were your creative arts teachers?

4. Do you like to sing? What is your vocal range?

5. What musical instrument(s) do you play?

6. Have you ever been in performances or recitals? If so, describe your participation—successes, fears, errors, family reaction, etc.

7. Do you like to knit, crochet, or quilt? How did you learn this skill?

8. Do you create other crafts or decorations? What kind? Why are these particular creative activities interesting to you?

9. Do you enjoy carpentry? What kind of projects interest you?

10. Do you enjoy photography, painting, sketching, or sculpture? If so, what are your favorite mediums and subjects?

11. Have you ever had your art or creations in an exhibit or show?

12. Do you enjoy participating in drama or play production? If so, how are you involved?

13. Have you ever acted in or directed a play? If so, which one(s) and what role(s) did you have?

14. Are interior decoration and design among your creative talents? If so, describe your projects.

15. Do you enjoy dancing? If so, in what way do you express yourself?

16. Do you enjoy writing? What subjects inspire your interest?

17. Have you had any of your writing published?

18. Describe any landscaping and exterior design interests and projects.

19. In what other ways do you express your urges?

20. How do you generate ideas?

21. When do you have your creative inspirations and what inspires them?

22. Have you ever suffered any creative blocks?
23. From which relative(s) did you inherit your creative talents?
24. Explain how your creativity has enriched your life.

> ***Items to show on camera:*** Art, crafts, musical instruments, publications, creative projects, and any videotape segments or photographs of your work.

Hobbies, Pastimes, and Talents

1. What hobbies have you enjoyed as an adult?
2. Do you have any creations that you'd like to share?
3. Have you ever had your creations exhibited?
4. What is your favorite hobby now?
5. Why did you choose this hobby?
6. How did you acquire skills for this hobby? Did you inherit these skills from a relative or did you have a mentor or coach?
7. Is this a solitary pleasure or a group activity?
8. Has your hobby ever generated income? If so, describe this benefit.
9. Is it hard or easy for you to allow yourself "play" time with your hobby?
10. Share some stories that relate to your hobbies.
11. What new hobby would you like to pursue?
12. Are you a collector? If so, describe your collections.
13. Which homemaking or home maintenance activities give you special pleasure?
14. Do you like to cook? Share some of your favorite recipes.

15. Tell us about a successful home improvement project that gives you pride.
16. Describe any flower or vegetable gardening projects that you have enjoyed.
17. What have been your favorite adult indoor and outdoor recreational pastimes—playing cards, active or spectator sports, taking nature walks?
18. Why do you participate in these activities?
19. What quiet activities do you enjoy?
20. How has spending time in this way rewarded you?
21. Who shares your pastime interests?
22. Share some interesting experiences about your pastimes.
23. What do you consider to be your special talents or gifts?
24. Were these talents innate or acquired?
25. How have you shared these talents with other family members or with others?
27. What pleasures or disappointments have these gifts brought you?
28. Does anyone else among your family or friends share the same gift(s)?

Items to show on camera: Photos of activities, relevant equipment, adventure paraphernalia.

Adventures, Great and Small

Describe your exciting and remarkable experiences, the adventures of your life you will never forget. Consider the following activities to stimulate your recollection process:

1. camping
2. hiking or exploring
3. mountain climbing
4. spelunking or cave exploration
5. boating
6. horseback riding
7. rodeo events
8. skydiving
9. waterfall jumping
10. parasailing
11. surfing
12. swimming with dolphins, manatees, or sharks
13. scuba diving
14. racing cars, bikes, speedboats, etc.
15. hunting or fishing
16. going on a safari
17. flying an airplane
18. sporting events
19. bungee jumping
20. any earthshaking event or historical moment, uplifting or horrible. Who, what, where, when, why?

Items to show on camera: Hobby and/or pastime photos, paraphernalia, collections, recipe cards, crafts.

Turning Points and Decisions

1. What have been the major turning points in your life?
2. In what ways do you feel that you have been "put to the test" by people or circumstances?
3. What forces caused these turning points—historical

events, external or internal influences, personal drives, and motivations?

4. How were others close to you affected by these turning points?

5. How did these turning points bring you fear, pleasure, pain, satisfaction?

6. Did you experience any "conversions" that marked changes in your beliefs or behaviors? If so, what did you have to release to achieve these changes?

7. Have you ever changed life direction completely? What caused this change(s)?

8. Have you ever had a total reversal of fortune? What precipitated this change? What were the circumstances?

9. Have you ever felt like you've been both a "before" and an "after"? Illustrate this metamorphosis with a story or anecdote.

10. Describe an "aha" moment when you suddenly understood something which you did not previously comprehend.

11. Did you arrive at this revelation on your own or with someone else's help? What factors created this revelation?

12. Describe a time when you took a serious risk. What were the results of taking this chance?

13. Ask yourself: If I had it to do again, I would:

14. Or: If I had it to do again, I would not:

15. Is it difficult for you to make decisions? Explain.

16. Describe some of the most difficult decisions you have had to make during your lifetime.

17. How did you arrive at your final decision?

18. Do you use a special technique or process when making a difficult decision?

19. What factors do you consider when making a difficult decision?

20. Are you usually more impulsive or deliberate when faced with choices?

21. When faced with the need for a quick decision, do you make it more with your heart or with your head?

22. Do you have any advice to share regarding conflict resolution and decision making?

23. Share a conflict which you have had and how you resolved this conflict.

24. What has been your most difficult decision regarding a job, your career, or the functioning of your family?

25. Have you ever made a decision that caused you to gain or lose financial security? Describe that decision and its ramifications.

26. Have you ever used "tough love" to help solve a problem? Explain.

27. Describe one of the worst decisions you have ever made.

28. Describe one of your best decisions.

29. Have you ever made a promise, then broken it? Why?

30. Have you ever had to make a really tough choice that cost you a relationship?

31. Whom do you admire for the ability to make decisions wisely? Share an example.

32. Describe a decision you had to make that you would never wish on anyone else.

33. How would you complete this phrase? "When in doubt about what to do…"

Politics

1. With which political party are you now affiliated? Why?

2. Have your party loyalties changed over the years? Why?

3. What presidential candidates have you voted for? Why?

4. Are you comfortable with the election process in your community?

5. Do you believe that your country's political system works? Why or why not?

6. Who has been the most effective president during your lifetime? Why?

7. Which president is your all-around favorite? Why?

8. In your opinion, which first lady has been the most effective? Why?

9. Do you think will that a woman should and/or will be elected as president during your lifetime?

10. Who has been your state's best governor?

11. Who have been the most effective senators and representatives from your state?

12. Which mayor of your city or county has had your respect?

13. If you have been closely involved in a political campaign, describe this experience—who, what, when, where, why.

14. Have you ever held public office? If so, share some stories about this experience.

15. Have you ever served as an election official at the polls? If so, what were some interesting situations which developed and how were they handled?

16. Do you have friends or relatives "in high places?" If so, tell about them.

17. Share some of your favorite political jokes or anecdotes.

18. What are your recommendations for better government—at any level?

19. "Politics makes for strange bedfellows." How does this saying apply to you?

20. How did various government periods or climates affect your life?

Items to show on camera: Political advertisements, slogans, posters, banners, buttons, letters.

Frightening Moments and Tough Times

1. Have you ever been involved in a serious automobile accident? Describe what happened.

2. Did you ever receive news of a terrible accident involving a friend or loved one? What happened and how did you react?

3. What other kinds of scares or bad news situations have you experienced?

4. Describe some of your close calls and what prevented them from materializing.

5. If you have ever been involved in a natural disaster, tell about the situation and how you reacted before, during, and after the event.

6. Have you ever feared for your own life? What were the circumstances?

7. What are some of your negative memories regarding

yourself or others involving abuse, addiction, unfaithfulness, deep hurts, imprisonment, major illness?

8. How did you react to and get through these situations?

9. Share some of your extreme disappointments—as a child, as an adolescent, as an adult.

10. Have any dangerous habits ever wreaked havoc in your life? How did you change them?

11. How do/did you make a comeback after a disappointment?

12. Which loved ones have you lost? How have you dealt with these losses?

13. What is your greatest fear now?

14. How do you cope with your fears?

15. What have been your sources of strength and hope during the difficult times, the disappointments, and the losses?

16. Talk about when times were tough for you and yours. How have situations changed for the better?

17. Have you ever worried about not having enough food or money to meet your basic needs?

18. Describe a day that you would like to forget.

19. Have you ever felt as if you were on trial for a crime? What were the circumstances? What was the outcome?

20. Did you ever have to start over after a major setback?

21. Would you describe yourself as a "survivor?" Why?

22. Do you ever have to help a friend through severe troubles? Explain.

23. What are your recommendations for dealing with adversity?

Amazing Coincidences

1. Describe any amazing coincidences that took place during your childhood and/or adolescent years.

2. Talk about unexpected meetings with people over the years, or of paths which have recrossed despite the odds.

3. What have been some helpful coincidences, "synchronicities," and fortunate timings pertaining to your work or career?

4. What have been some lucky, unexplainable experiences in your personal life?

5. Describe an unlucky experience you had.

6. What is your opinion of synchronicity, or the belief that "There are no accidents, and everything is a meaningful coincidence."

7. What accidents or dangerous situations have you avoided because amazing coincidences have intervened?

8. What is your attitude about "going with the flow" of whatever life brings?

9. Do you support the notion that no experience in life is wasted? Why or why not?

10. Describe some unexpected opportunities which have arisen, causing new doors to open for you.

11. Share an example of how "being in the right place at the right time" led to positive developments for you.

12. Talk about how any surprising phone calls, letters, or e-mails have changed your life—for better or worse.

13. What fortunate coincidences, synchronicities, or circumstances have enabled you to move ahead into areas you had not previously considered?

14. Where do you stand in the "fate vs. free will" philosophical debate?

Forging Your Own Way

1. What is your reaction to the old saying, "No pain, no gain"? Has this applied to any of your life experiences?
2. Have you ever used creative visualization to achieve a goal or dream? If so, describe the circumstances.
3. Has "The Self-fulfilling Prophecy" ever been enacted in you or others? If so, how have you experienced this phenomenon?
4. If you have ever used affirmations or positive goal statements to set, focus on, and achieve your goals, share the process and results of these approaches.
5. When and how did you learn to trust your own intuition?
6. Describe some positive experiences that resulted when you followed your own intuition, despite the advice of others.
7. Share a story about how you have beaten all of the odds and gained success for your efforts.
8. What kind of "scripts" or "programs" were developed for you early in your life?
9. Did you live your life your way or as others have planned it for you?
10. How well have you followed the positive road maps that others prepared for you?
11. What traits do you consider to be important for achieving personal goals?
12. What attributes make you special?

13. What roadblocks or challenges have interfered with your achieving your desired goals?

14. How did you adjust to or overcome these setbacks?

15. Which people have helped you to achieve your personal goals?

16. When and how did you navigate past the myths and insecurities about yourself to discover the real you?

17. Did you ever perform a heroic or noble act? Describe the circumstances and outcome. How did you feel about it before, during and after the fact?

18. What have been some of the pleasant surprises along your carefully planned path?

19. Was a having a formal education a major factor which enabled you to achieve your goals?

20. What is your definition of success? Has it changed over the years?

21. In what ways have you been successful, by your own definition and standards?

22. What praise and awards for your accomplishments have you received from others?

Items to show on camera: Awards, commendations, certificates, medals, plaques, trophies.

The Middle Years

1. Did your life begin at forty? Explain.

2. Describe the changes in your appearance during your middle years—age forty to sixty.

3. What proportion of your time during these years did you spend on work, family, recreation, and hobbies?

4. What personal interests did you pursue during these years?

5. Share three significant memories from these years.

6. How did your relationships with your spouse or significant other evolve during this period?

7. Were there new romantic involvements?

8. If you have children, how did your relationship with them change as they grew older?

9. Describe your interactions with your parents and siblings?

10. Did you make new close friends?

11. Did anyone close to you die? What were the circumstances? How did this loss affect you?

12. If you have children, when did they become independent?

13. Did you suffer from the empty-nest syndrome when they moved out?

14. What kinds of entertainment did you enjoy?

15. Were you financially comfortable during these years or did you have concerns?

16. If you had a mid-life crisis, describe it.

17. Describe the functioning of "the child in you" during these years.

18. Did you ever feel that you were a member of the "sandwich generation," juggling your time and energy to meet the needs of children and parents simultaneously?

19. Were you involved in caring for elderly parents or other family members?

20. If you could change one thing that occurred during this time of your life, what would it be?

21. What advice would you give to those approaching or in their middle years?

Grandchildren and Great-grandchildren

(Repeat for each grandchild and great-grandchild.)

1. Were you eager to become a grandparent?
2. How did you react to the news of a grandchild on the way?
3. How involved were you in your grandchild's birth and infancy?
4. What is the full name of your grandchild?
5. Who gave your grandchild this name? Why?
6. How old is this grandchild now?
7. What are his or her physical traits?
8. How would you describe his or her personality?
9. What does this grandchild call you? Why?
10. What are his or her talents? What weaknesses or challenges does he or she have?
11. Does he or she have special interests?
12. Where does your grandchild live now?
13. How often do you get to see this person?
14. What do you enjoy doing with this grandchild?
15. Have you spoiled this grandchild? In what way(s)?
16. Share some cherished stories about this grandchild.
17. What are some of his or her cute or memorable words or sayings?
18. What advice can or did you give your own children about parenting?
19. What advice or thanks would you like to give this grandchild?

20. What kind of world do you think your grandchild will inherit?

> ***Items to show on camera:*** Photographs of each child at different ages, school work, sports trophies, art work, report cards.

My, How Things Have Changed!

1. Do you still live in an area near your childhood home? Describe the changes you have witnessed in your neighborhood, town, or community.
2. How much time do you now spend with your own family—spouse, significant other, children, grandchildren, and siblings? How does this compare with the family time you had as a child with your parents and siblings? What are some of the demands which encroach upon your time together?
3. What have been some of the changes over the years in

 - clothing, hair styles
 - social manners and customs
 - furniture construction and style
 - automobiles
 - methods of food preparation and housekeeping

4. Which of the trends and developments above did you welcome? Which did you resist? Why?
5. What was life like before the invention or widespread use of some of our modern conveniences, like indoor plumbing, laundry, kitchen appliances, TV, and computers?

6. Which modern inventions have had the most positive effect on your lifestyle?

7. Describe dramatic developments you have witnessed during your life in the following areas:

- prices and paychecks
- health care and medicine
- education
- communications technology
- transportation and travel
- science, explorations
- sports
- humanities and the fine arts
- philosophy, history
- religion
- civil rights
- roles of men and women
- growth in your community
- role of your country in global politics
- environmental issues
- other

8. Which of these changes do you consider to be positive? Which are negative?

9. How did these periods or events impact your life?

- The Roaring Twenties
- The Great Depression
- John F. Kennedy's death
- The hippie era
- Foreign Wars (WWI through the Afghan War)

- The Cold War
- Local political scandals
- The destruction of the Twin Towers in New York City

10. Describe some aspects of the "good old days" that were not really all that good.
11. How have your personal attitudes, beliefs, and values changed over the years?
12. How can young people prepare for the inevitable changes the future will bring?

Items to show on camera: Dated household items, appliances, antiques, cars, farm equipment, sports gear, clothing.

Some Things Never Change

1. In what ways are you the same person you always were?
2. What aspects of your personal life have remained constant over the years?
3. What components of your community, country, or world have resisted change?
4. What favorite pastimes from your early years are you still involved in today?
5. In what ways would you consider yourself "in a rut"?
6. What parts of your family, social, and community life seem stagnant and in need of change?
7. "Thank goodness, some things haven't changed." What non-changes are you happy about?

8. "Some things never change, but I wish they would." What changes would you like to witness or help bring about? In what way would you like to change one or more of the following?

- your home
- your community
- the country
- the world
- your health
- your own attitudes and values
- the attitudes and values of others
- an aspect of your life
- other (sports, religion, communication, education, politics, Social Security, etc.)

9. How can you and others help bring about these changes?
10. Describe some highlights of "the good old days" from your perspective.
11. Do you usually view change as growth or as a threat? Explain.
12. If you could wish for one thing to remain unchanged forever, what would it be?

Spirituality

1. What is your first memory of being involved in a religion?
2. Describe your religious training. How did you feel about it?

3. What is your present religious affiliation?

4. What church, temple, or synagogue participation have you been involved in over the years?

5. What were the religious or spiritual philosophy and beliefs of your parents?

6. Did/does your family pray together? On what occasions?

7. Were/are there religious objects or images in your home?

8. What were/are some of the requirements and practices of your religion?

9. What was/is forbidden in your religion?

10. Did you adhere to the prescriptives of your religion?

11. If your family was not religious, how did this affect you?

12. If religion or spirituality has never been an important part of your life, why?

13. If you were baptized, describe the occasion.

14. How, when, and where did you receive your religious or spiritual training?

15. Did you participate in church, synagogue or temple youth activities? When and where?

16. Explain the circumstances of your affirmations and/ or reaffirmations of faith.

17. What was your attitude towards religious or spiritual authority figures and teachers?

18. If you were confirmed, or had a Bar/Bas Mitzvah, where, when, and how did this take place? Was this experience meaningful for you at that time?

19. In what other religious rituals have you been a participant—marriages, funerals, confirmations, Bar/Bas Mitzvahs, etc.?

20. Have you ever questioned your faith? Explain.

21. Did you explore religious or spiritual beliefs other than the one in which you were raised? With what results?

22. Describe your personal relationship with God.

23. Share some of your spiritual experiences.

24. Were you ever ashamed of your religion?

25. Have you been persecuted because of your religious beliefs?

26. Does talk of religion make you uncomfortable?

27. Do you believe in miracles? If go, describe some miracles you have witnessed or experienced.

28. Do you believe in angels? If so, share some angel stories about yourself or others.

29. Describe your feelings about and personal experiences with the power of prayer.

30. What are your favorite hymns or scriptural passages, stories, verses, and prayers?

31. What have been your spiritual growth milestones?

32. Who have been your spiritual guides, teachers or leaders?

33. Are your values grounded in your religious beliefs?

34. Did you raise your children in your own faith and with your spiritual values?

35. Do you believe in life after death?

36. In your opinion, what is the relationship of ethics and religion?

37. Talk about the role of spirituality or religion in your life today.

38. If you do not consider yourself a religious or spiritual person, how do you find meaning in life and inner peace?

> ***Items to show on camera:*** Photos of churches you have belonged to, religious/spiritual records, certificates, family Bible or other spiritual resource book, hymnal, symbols, icons, jewelry.

Mixed Emotions

Respond to memories which are evoked by any of these words.

admired	dynamic	important
adorable	enchanted	inspired
afraid	excited	intense
alone	excluded	intimidated
amused	exhausted	jealous
authoritative	fantastic	jilted
awkward	foolish	kind
bewildered	forceful	loving
bold	forgiving	low
brave	fragile	majestic
brilliant	furious	mean
broken	generous	moody
cheerful	grief	moral
comforting	grim	nauseated
confident	happy	neighborly
confused	hateful	nervous
contented	helpless	numb
cruel	heroic	offended
crushed	honest	optimistic
disgusted	honored	overwhelmed
defiant	hurt	panicky
devoted	impatient	peaceful

pity	skillful	truthful
proud	sorry	turbulent
puzzled	speechless	understanding
regretful	stranded	vindictive violent
reliable	surprised	vivacious
ridiculous rude	sympathetic	vulnerable
ruined	tender	warm
sad	thoughtful	weak
sensitive	thrilled	worried
shy	titillating	wonderful
silly	tormented	worthless

Favorites

Describe who or what qualify as your favorites in the following categories and explain why.

actor	magazine
actress	band or orchestra
play/ musical	musical group
movie	vocalist
entertainment	song
entertainer	opera
television show	painter
radio program	painting
director	sculptor
author	sculpture
book	dance group
poet	dancer
poem	athlete
newspaper	participant sport

spectator sport	flower
game	tree
automobile	bird
water craft	water creature
recreational equipment	insect
food	domesticated animal
restaurant	wild animal
recipe	animal totem
clothing: hat, shoes, suit	saying
jewelry	quotation
furniture	joke
knickknacks or collectibles	comedy performer
personally owned art	political figure
fine china,	historical figure
crystal	religious leader
linen	scientific figure
family heirloom	taste
appliance	smell/aroma
invention	sound
color	touch
season	sight

Childhood Role Models and Mentors

1. Whom did you look up to as a hero or heroine during these years? Why?
2. How did they influence your growth and development?
3. Share some memories of the times you spent together.
4. Have you ever told them how much you respect and admire them?

5. Did you think of any book or cartoon characters as your heroes? Which ones?

6. Who were some of your childhood guides, mentors, or coaches?

7. What did they teach you or how did they influence you in a positive way?

Adulthood Role Models and Mentors

Considering the various areas of your education, your work or career, your spiritual growth, and/or your personal development:

1. Who have been your role models during your adult years?

2. Why did these people inspire you?

3. How have they influenced you in a positive way?

4. Who have been your adulthood mentors, guides or coaches? How were they helpful?

5. Have you ever been a mentor or guide to another person? Describe the circumstances of this relationship.

6. Have you ever been considered a role model by another person? Explain.

7. How do/did you feel about being a role model or mentor?

8. Which famous public figures do you now consider as heroes or role models?

9. What are your reasons for respecting them?

10. Is there someone you would like to mentor now or in the future?

Unforgettable Characters and VIPs

1. Taking your cue from the Reader's Digest's section, "The Most Unforgettable Character I Ever Met," who would be yours?

2. Tell about people you have known who are the most:

 - nurturing
 - beautiful
 - interesting
 - difficult
 - adventurous
 - honest
 - lovable
 - unusual
 - courageous
 - modest
 - enthusiastic
 - confident
 - creative
 - patient
 - understanding
 - faithful
 - naughty
 - witty

3. How might you be considered an unforgettable character by others?

4. What qualities do you most admire in other people?

5. What kinds of people irritate you and are negative VIPs?

6. Who are/have been the Very Important People (VIPs) in your life?

7. Explain why they qualify as VIPs.

8. Have you ever known a famous person or celebrity? Describe your acquaintance.

9. Do you feel comfortable around VIPs?

10. Are you a VIP to someone? Who holds you in this regard and why?

Faithful Friends and Fearsome Foes

(Repeat as desired for childhood, adolescent, and adult friends or foes.)

1. What is your definition of friendship?

2. What traits do you value in a friend?

3. Who have been your best friends during various times of your life?

4. Where and how did you meet these best friends and get acquainted?

5. What did you and your friends do/share together— daily activities, projects, trips, adventures?

6. Why was each person your best friend at a given time in your life?

7. Describe this friend.

8. How would this person describe you?

9. Are you still in touch with him or her? How do you communicate now?

10. Why have you remained friends—or not?

11. What has this friendship meant to you?

12. What did you learn about friendship from this relationship?

13. Share some favorite friendship stories.

14. In what ways have your friends enriched your life?

15. How have you tried to be a companion and offer support?

16. Have you ever been deeply hurt by a friend? What happened? How did you handle the situation?

17. Within your own family, who has been a good or best friend?

18. Who have been some of your fearsome foes?

19. How did you meet this person and begin to interact?

20. Describe this enemy and explain why you did not relate well to each other.

21. What battles did you fight? Who were your allies?

22. How did you cope with this person?

23. Were you able to resolve your differences and/or problems? How?

25. Do you know what has happened to this person? Are you still communicating?

26. What did you learn from this relationship?

27. Can you think of someone who has been more of a nemesis than an enemy?

28. If so, in what way? What were the circumstances? How did you resolve the situation?

29. Have some of your personal conflicts led you to greater strength and self-confidence?

30. In what way(s) have you been "your own worst enemy?"

Secrets— True Confessions

Now is your chance to reveal some previously unknown or

little known facts about yourself. You must be the judge of the extent to which you feel comfortable about sharing these secrets. (If you don't tell, we'll never know.)

1. What do people believe about you that is incorrect?
2. Share with us some stories that no one has ever heard before about your:

 - parents
 - siblings
 - children
 - spouse
 - friends
 - boyfriend/girlfriend
 - childhood
 - adolescence
 - early adulthood
 - middle years
 - senior years

4. Share some of your raunchy, rotten moments that no one knows about.
5. Now it's time for "True Confessions." Bare it all, get rid of your guilt, and sleep well tonight!
6. Describe any "Ghosts from the Past" that return to haunt you now and then.
7. Are you hiding any "skeletons" in your closets? If so, now may be the time to let them out! Name them.
8. Over the years, have you discovered any family secrets that you'd like to share?
9. Are there any mysteries that you'd like to have clarified or explained?

10. Do long-standing misunderstandings or strained relationships cloud your happiness?
11. Do you have a secret place where you go to get away from it all?
12. What was the hardest secret you ever had to keep from someone?
13. If you could read someone's secret thoughts, whose mind would you like to explore?

Fantasies, Pipe Dreams and Real Dreams

Childhood:

1. What fantasies did you have as a child?
2. Did you ever confuse fantasy with reality? Explain.
3. Do you remember any of your real dreams during these early years?
4. Did any of these dreams come true?
5. Do you remember any of your childhood nightmares?
6. How were you and your family affected by these nightmares?

Adolescence and Adulthood:

1. Describe some of your pipe dreams, giving no consideration to time, cost, physical, or other possible constraints.
2. Are or were these hoped-for dreams spawned by your naivete or are/were they plausible?
3. Did any of these pipe dreams materialize? Explain.
4. Do you remember any of your real dreams from these years?
5. Have any of them come true?

6. Are or were you a daydreamer at times? If so, describe some of your daydream escapes.

7. If you have had recurring dreams, share some of them.

8. Have you had nightmares during these years? How did they affect you?

9. How do you cope with bad dreams now?

10. Have you ever received an important message or an answer to a question during a dream?

11. Have you ever been visited in a dream by a loved one who is deceased or lives far away?

12. Do you remember most of your dreams?

13. Do you dream in color or in black and white?

14. Share with us a dream that you will never forget.

15. If you could make any fantasy a reality, what would it be?

16. What has been the most magical moment of your life?

The Later Years—Retirement

1. What are your feelings about growing older?

2. What are some of the advantages of age?

3. What are the disadvantages of being old?

4. Which five words best describe you now?

5. Many labels exist for those who have achieved great maturity. Which do you prefer to be called—senior, senior citizen, elder, gray panther, or other term?

6. How do you like being labeled in this way?

7. Describe your current health.

8. Is your financial status satisfactory?

9. What other issues or concerns need attention at this point in your life?

10. Who are the most important people in your life now?

11. Share some "Senior Moments" that you have experienced recently.

12. Explain why having a sense of humor is especially helpful now.

13. If you have retired, when did you do so?

14. Why did you retire?

15. How did you feel as you approached your retirement?

16. Did your spouse or significant other retire at about the same time or at a different time?

17. What, if any, post-retirement adjustments did you have to make?

18. Did you move to a new community after retirement? If so, why?

19. How do you feel about your retirement now?

20. What are the advantages and disadvantages of being retired?

21. In what ways has your life changed with retirement?

22. Did retirement bring you a new career or new interests?

23. Is retirement what you anticipated? Explain.

24. What fears do you have at this stage of your life? How do you cope with them?

25. What goals have you set for your retirement years?

26. What might need to happen to help you achieve these goals?

27. What is your advice on how to stay young—at heart or otherwise?

Leaving Your Legacy

1. What legacy will you leave to your family? What will they inherit from you?
2. What do you hope you have given to your community, to your country, to the world?
3. What contributions have you made to your work area or career?
4. What do you count as your greatest successes and achievements?
5. For which accomplishment would most like to be remembered?
6. How would you answer the question, "What are you worth?"
7. How important have money and financial security been to you?
8. What have you valued most in life?
9. What five words would you like for others to use in describing you?
10. What compliments have you received from others? What were the circumstances? Don't be modest.
11. How have you left the world a better place?
12. What are your negative traits?
13. Share some "words to live by" that have become part of your philosophy.
14. What other "words of wisdom" would you like to pass on?
15. Show and tell the history of your family's coat of arms, kilt design, or other heirlooms.
16. What family stories have you helped keep alive from generation to generation?

17. Describe some important lessons you have learned along the way in your life journey.

18. What were the nonmaterial gifts given to you by your parents? Your spouse or significant other? Your children? Your friends?

19. Have you made a "living will" to inform loved ones of your wishes should you become disabled or terminally ill? If so, where is it located and who has access to it?

20. Where are important insurance policies and other documents kept? Who has access to these documents?

21. Are there any special instructions you'd like to share about these materials?

22. Would you like to identify any professionals who have been in your service: lawyers accountants, insurance agents, etc.?

23. Have you made a last will and testament? If so, where is it located and who has access to it?

24. Have you made an official request to be an organ donor?

25. If you wish, share any special desires you may have regarding your funeral, memorial, and burial services.

26. Are there favorite words, songs, or thoughts that you would like to have included in these services?

27. Where would you like to be laid to rest?

28. What words would you like to have inscribed on your memorial?

29. Which have been the best years of your life? Why?

30. If you could go back in time and change something about your life, what would it be? How and why would you change it?

31. If you could stop the clock at any age of your life, when would you stop time?
32. What have been the highlights or milestones in your life?
33. If you could choose a symbol for your life, what would it be?
34. As you review the personality traits of family members for several generations, how have you fit into or broken the mold?
35. With whom would you like to have these video memoirs shared?

What I Want to Do Next

1. What would you like to do

 - tomorrow
 - next week
 - next month
 - next year
 - in five years
 - in ten years, etc.

2. With whom would you like to do these things?
3. What would you like to learn?
4. How much would you like to earn?
5. What would you like to create next?
6. Where would you like to visit or travel in the future?
7. If you could have three wishes, what would they be?
8. If you could be anyone in the world now, who would you choose to be? Why?

9. Describe how you fit into the future of your family, your neighborhood, your community, your country, the world.

10. Share some of your current hopes, dreams, and goals.

11. What personality traits or personal possessions would you still like to acquire?

12. How do you intend to fit into the 21st century?

Editing

By now you have created the raw material for something unique: your memoirs.

Editing is the next step—the process of arranging your videotaped segments into a logical sequence, possibly adjusting the length of the segments, then polishing the final edition. You may wish to add titles or even subtitles and captions to each segment of the finished piece. You can do this with any of several methods, such as using simple chalk or white boards, posters, overlays, or a superimposer feature on an expensive camera. You may want to tape an introduction in which you share your reasons for leaving your videotaped legacy. If you like, you may consider dedicating your memoirs to someone, to some idea, or to a noble purpose.

To add variety to your videotaped memoirs, you can edit in "cutaways," or related shots—like to showcase the furniture handed down to you from your grandparents. You can also insert "cut-ins," which are detailed close-ups of a person or an object, perhaps a genealogical page from the family Bible, a baseball mitt you used as a child, or a favorite piece of jewelry. These insertion techniques provide welcome transitions in a lengthy interview.

Music can be edited in with nice effect, especially during the opening and ending moments of a scene or even throughout the entire piece.

If you wish to combine, shorten, or omit portions from your videotaped segments, consider tape-to-tape editing. You can record specific scenes from your camcorder directly onto a tape in your VCR. But this shortcut method can leave you with bad, snowy edits. Using an *Editing unit,* you can transfer material from the original tape onto another tape with the machine making those hard-to-control edits for you, once you choose the scenes you want.

> "The longer I live, the more life becomes."
> —Frank Lloyd Wright

If you have a digital camcorder, you'll want to edit on your computer. There are many different brands of software for video editing. These programs range to from those designed to be used by everyone from the greenest beginner to the most accomplished professional. Check with a computer specialist for today's brands and prices.

For even more sophisticated editing, consider getting the help of professional video editors. Use your Yellow Pages to locate one or ask at a video retailer for a referral.

While you probably think that you have completed your memoirs, you may have just begun. Keep a note pad handy while reviewing your video so that you can jot down other stories that come to mind. Then set time aside to videotape an update.

Later, you may wish to create additional volumes of your memoirs or insert segments into the current volume. Your life is still in progress, and you probably have many more "miles to go before you sleep." Keep sharing your stories and editing them in.

9

Preserving the Legacy

Following these simple precautions will ensure that your videotaped memoirs will be around for years to come.

Make at least one extra copy and tell one or more of your loved ones where it's located—perhaps in a safety deposit box or fireproof safe. Even better, make multiple copies and scatter them around, spreading both your good memories and good will among the folks who love you.

Do not use original tapes for viewing because each screening will diminish their quality. Make as many copies of the originals as you wish. These "first generation" copies can be viewed again and again. If they need to be replaced or duplicated, reproduce new tapes from the originals.

Keep your original tapes in a safe place where they are not exposed to extreme temperatures (attic, basement, direct sunlight) or high humidity or moisture in the air. Do not place originals or copies near magnetic sources (TV, electrical devices, magnetic children's toys). Keep them clean and away from spills and dirt.

Be sure that they are clearly marked and recognized as heirlooms so that they are not accidentally recorded over. To help pre-

vent this kind of loss, find the record protect feature on the tape, which may be a tab or a slide gate, and activate it.

Stand originals and copies of videotapes on their edges, like books in a library, in protective cases or sleeves. Rewind tapes before storing them.

If they will not be fully played for long periods of time, *fast-forward, then rewind them*—at least once every three years. *Copy valuable recordings every ten years*, creating a new "master" which can then be used for additional copies.

Finally, invite loved ones of all ages to view your video memoirs. Do not hide them away. Share them, and share them often. Of what value are they if they are not seen?

Perhaps your work will inspire others to create their own video memories. Even children have stories to share which may get lost through the years if they are not recorded while they are fresh. What a treasured library of video memories you can all assemble—about the times of all of your lives!

Resources

Check the business section of your local telephone directory under the following headings if you feel you need further assistance with creating your very own priceless video memoirs:

- Photographic Equipment and Supplies-Retail
- Camcorders Craft Supplies—Albums and Scrapbooks
- Videocassette Recorders
- Video Production Services
- Videotape Duplication Services

You may also wish to explore some of the following recommended readings and other resources. One good thing often leads to another!

Books

Balhuizen, Anne Ross. *Searching on Location: Planning a Research Trip.* Salt Lake City: Ancestry, 1992.

Beal, Steven. *The Complete Idiot's Guide to Making Home Videos.* New York: Alpha Books, 2000.

Bramann, Jorn K. *Camcorder Art: What to Do with Your Video Camera after You Read the Operating Manual.* Cumberland, MD: Nightsun Books, 1992.

Dixon, Janice T. *Family Focused: A Step-by-Step Guide to Writing Your Autobiography and Family History.* Bountiful, UT: Heritage Quest, 1997.

Editors of *Videomaker Magazine. The Videomaker Handbook: A Comprehensive Guide to Making Video.* Boston: Focal Press, 1996.

Fuller, John G. *Make Fantastic Home Videos: How Anyone Can Shoot Great Videos!* Amherst, NY: Amherst Media, 1996.

George, Chris. *Camcorder.* Lincolnwood, IL: NTC Publishing Group, 1994.

Greene, Bob. *To Our Children's Children.* New York: Doubleday, 1997.

Hodges, Peter. *The Video Camera Operator's Handbook.* Woburn, MA: Butterworth-Heinemann, 1995.

Lewis, Roland. *101 Essential Tips Video.* New York: Dorling Kindersley, 1995.

_____. *Learn to Make Videos in a Weekend.* New York: Alfred A. Knopf, 1993.

Merrill, Joan. *Camcorder Video: Shooting and Editing Techniques.* Englewood Cliffs, NJ: Prentice-Hall, 1992.

Millerson, Gerald. *Video Production Handbook.* Boston: Focal Press, 1992.

Stavros, Michael. *Camcorder Tricks & Special Effects.* Amherst, NY: Amherst Media, 1999.

Wagner, Edith. *The Family Reunion Sourcebook.* Los Angeles: Lowell House, 1999.

Magazines

Memory Makers. Subscription Department, P.O. Box 7253, Bensenville, IL 60106-9530.

Reminisce. Reiman Publications, P.O. Box 992, Greendale, WI 53129-0992.

Videomaker. P.O. Box 469026, Escondido, CA 92046-9838.

Videotapes

Cartwright, Gene. *How to Shoot Videos Like A Pro: Introducing Katie Crooks.* Baldwin Park, CA, Cinemagic, 1990.

Pierce, Kerry. *Duplicating and Editing Your Home Video.* Canby, OR: Gordian Productions, 1996.

How to Shoot Better Home Videos: Step by Step Instructions from a Professional Videographer. Southfield, MI: Patrick Sean Productions, 1993.

Video Camcorders: Your Guide to Making Successful Home Videos. Quebec, Canada: How-We-Do-It Productions, 1993.

Web Sites

Triggering Memories: www.triggers.com

Turning Memories: www.turningmemories.com

Index

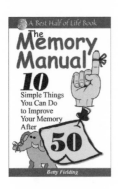

The Memory Manual
10 Simple Things You Can Do to
Improve Your Memory After 50
by Betty Fielding

*"...very specific, practical
advice...encouraging."*
—Mary Linnehan, Director,
Elderhostel Institute Network

• Do you forget appointments?
• Tired of looking for where you left your car keys?
• Embarrassed when you forget the name of someone you've just met?
• Wish you could remember more details about what you read?

Then *The Memory Manual: 10 Simple Things You Can Do to Improve Your Memory After 50* is the book for you! No gimmicks, no long codes or systems to study and memorize, just a simple, holistic program that will get you or a loved one on track to a better memory and a fuller life!

It's Never Too Late to Be Happy!
Reparenting Yourself for Happiness
by Muriel James

"A wonderfully encouraging book for turning our lives around."
—Reiko Homma True, Ph.D.,
University of California San Francisco,
Department of Psychiatry

In the field of psychology, self-reparenting is recognized as a highly effective strategy for pursuing happiness.

With *It's Never Too Late to Be Happy*, Muriel James, coauthor of the 4-million-copy best-seller *Born to Win*, presents a clear, layman-friendly self-reparenting program through which the reader can actually create a new internal parent—one which is fully functional, supporting, encouraging, and loving—to replace the old parent figure, whose negative psychological messages consistently thwart one's hopes for happiness.

**Available at better bookstores, online bookstores
or by calling toll-free: 1-800-497-4909
QuillDriverBooks.com**

About the Authors

Suzanne C. Kita is a writer, editor, teacher, and education consultant. She has taught both in public and private schools and in community colleges. She lives in the Rocky Mountains near Bailey, Colorado, where she facilitates workshops for writers of all ages and writes on environmental issues for children and adults.

Harriet Kinghorn was honored as "Teacher of the Year" in East Grand Forks, Minnesota, and received the Doane College Alumni Educator of the Year award. She has authored and coauthored more than thirty educational books. In 1995, her *Every Child a Storyteller: A Handbook of Ideas*, written with Mary Helen Pelton, won the Storytelling World Award.